Eva Mendgen

FRANZ VON STUCK

1863-1928

"A Prince of Art"

Benedikt Taschen

FRONT COVER:
Salome (detail), 1906
Oil on canvas, 115.5 x 62.5 cm
Munich, Städtische Galerie im Lenbachhaus

ILLUSTRATION PAGE 1:
Ex libris, 1906
Estate of the artist

ILLUSTRATION PAGE 2:
Jochen Poetter
Franz von Stuck and the Villa Stuck, 1982
Photomontage

BACK COVER:
Self-Portrait, 1899
Selbstporträt
Oil on wood, 42.5 x 35.5 cm
Nuremberg, Germanisches Nationalmuseum

© 1995 Benedikt Taschen Verlag GmbH
Hohenzollernring 53, D-50672 Köln
© 1994 VG Bild-Kunst, Bonn for the works by
Albers, Kandinsky and Klee
Layout: Christine Traber, Cologne
Cover design: Angelika Muthesius, Cologne
English translation: Charles Miller, New York
Copy edited and typeset by First Edition
Translations Ltd, Cambridge

Printed in Germany
ISBN 3-8228-8888-5
GB

Contents

6
"Munich Shone"

12
The Road to Success

18
"A Woman to Drive You Insane"

28
The Prince of Art

48
Franz von Stuck the Aristocrat

70
Under the Sign of Pan

86
Prince and Teacher of Art

92
A Chronology

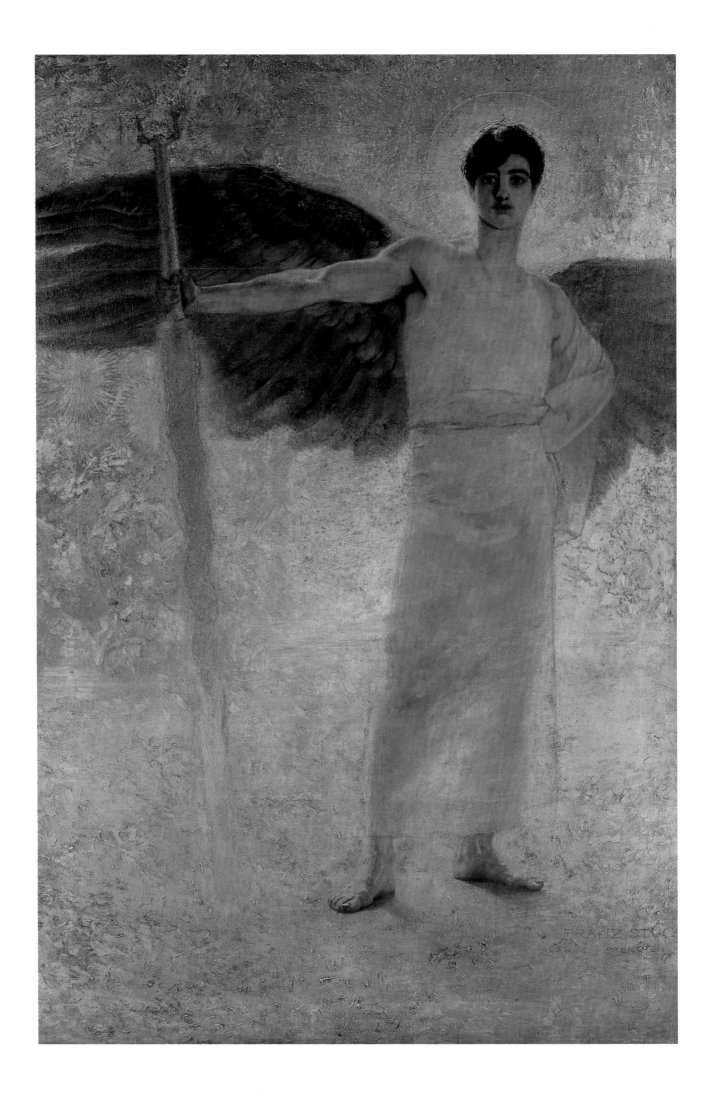

"Munich Shone"

Franz Stuck's swift rise to pre-eminence began in 1889, when he was twenty-six years old. In that year Stuck exhibited for the first time, showing three paintings at the Munich Crystal Palace (ill. p.7). For the large-size painting *The Guardian of Paradise* (ill. p.6) he received a gold medal, second class, with prize money of 60,000 marks, approximately ten times the annual earnings of a labourer.

Franz von Stuck was the son of a miller and was born in 1863 in the village of Tettenweis, Lower Bavaria. After finishing at secondary school he prevailed upon his parents to support him at the College of Arts and Crafts and then at the Academy of Fine Arts in Munich. From his very first showing in 1889 he achieved remarkable success with the public. In 1892, as one of the founder members of the Munich Secession, he joined the artistic avant-garde of the German Reich. The following year he was appointed to a royal professorship; from 1895 he directed the painting class at the renowned Munich Academy of Fine Arts; and in 1905 he was elevated to the aristocracy.

At the turn of the century, Stuck was one of the most famous and popular artists in Europe, and his name was inseparable from the youthful rebellion of the Munich Secession. Even after the turn of the century, when his work came to be seen as old-fashioned, in the judgement of foreign critics his name was still "synonymous with modern Munich art, which he personified in its richest potency".

Stuck's sensational showings were often attended by minor scandals. Posters reproducing one of his paintings displayed in the windows of Munich art dealers were banned by the police. Stuck's female nudes, a kind of Bavarian *femme fatal* in the guise of sphinxes, Amazons or personifications of sin (ill. p.18) and sensuality, are seductive figures, painted with a forceful directness that can be disconcerting even today. Presided over by the god Pan, now reflective and now lecherous, a case of centaurs, nymphs and other figures from classical mythology give full vent to their lascivious drives. The paintings were rigorously composed works which dispensed with unnecessary narrative detail; and everyone had a view on them. The poet Otto Julius Bierbaum maintained that Stuck's success was founded in his "sensuous power to communicate through colours and forms those same feelings of pleasure he had himself when he looked at something that inspired him to paint".

In *The Guardian of Paradise* Stuck depicts a larger-than-life, muscular young man with an invitingly erotic air about him. Its subject matter was not the only aspect of this painting that aroused contemporaries when it was seen at Stuck's first showing at the Crystal Palace in 1889. The novelist and journalist Theodor Fontane described the work, when exhibited in Berlin, as a "gigantic portrait in an enigmatic kind of heavenly atmosphere, nothing but white, purple and pink blobs, some half a finger thick". Fontane liked the painting for its

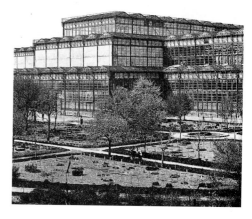

The Crystal Palace, Munich, c. 1890
Photograph
The Crystal Palace was built in 1854 in imitation of London's Crystal Palace. It served as an exhibition hall for industrial products and contemporary art.

The Guardian of Paradise, 1889
Der Wächter des Paradieses
Oil on canvas, 250 x 167 cm
Munich, Museum Villa Stuck
Stuck received a gold medal for this painting when it was exhibited in 1889 at the annual exhibition of the Munich Artists' Association. Despite the award, the young artist incurred the censure of the conservatives who dismissed the work out of hand as "mere daubing".

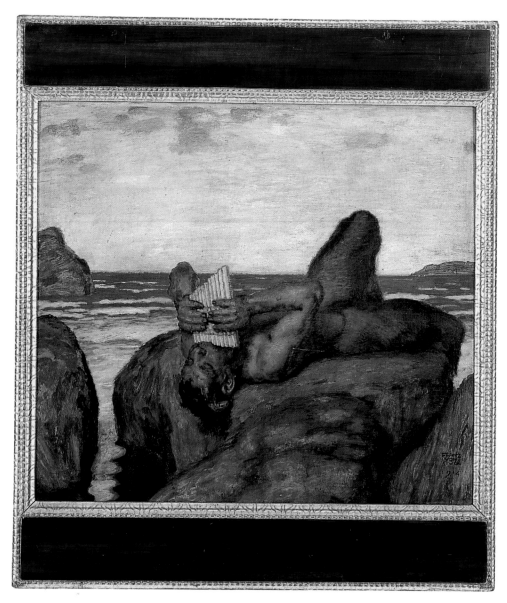

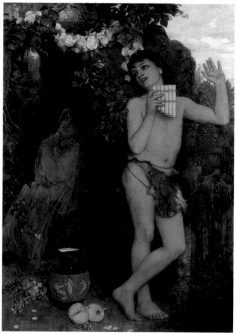

Faun Blowing Syrinx Pipes by the Sea, 1914
Syrinx blasender Faun am Meer
Oil on wood, 70 x 79 cm
Munich, Museum Villa Stuck
Stuck was preoccupied with faun motifs
throughout his career, as was Arnold Böcklin
on whose work he modelled his own.

Arnold Böcklin
Daphnis and Amaryllis, 1866
Daphnis und Amaryllis
Oil on canvas, 137.9 x 100.4 cm
Munich, Bayerische Staatsgemälde-
sammlungen, Schack-Galerie
The Swiss Idealist painter Arnold Böcklin,
one of the most important influences on
the German Secessionists and Art Nouveau
artists, was popularly known as the "great
Pan". His paintings are filled with figures
from classical mythology such as nymphs,
centaurs and fauns.

"poetic" qualities, while others spoke of "daubing" and could see only a "manservant" in the angel. Either way, this painting marked out Stuck as a modern. To his contemporaries the young painter was revolutionary in "giving up the studio style, with its academic–classical airs and graces, for thorough-going plein-air technique".

But he was not a Naturalist who painted "young peasants, agricultural workers and ordinary boys", nor was he a true plein-airist who placed land-scape at the centre of his work. What was important was that Stuck "turned away from Naturalism and painted that guardian of paradise, a figure that human eyes could never see and had never seen". With this work Stuck placed himself in the tradition of the "painters of the soul and the mind", whose best-known representative at this time was the Swiss painter Arnold Böcklin, whose work Stuck expressly referred to as a model for his own.

This early painting of Stuck's was also intended as a manifesto directed against the Munich historical painters and the so-called "*Lederhosen*" school, and the work's individuality made its programme a highly auspicious one, offering the first serious competition on the international art market to the foreign plein-airists, Symbolists and Naturalists whose work sold better at Munich Crystal Palace exhibitions than the work of German artists. Foreign painters exhibited at the Crystal Palace included Frederic Lord Leighton, Sir

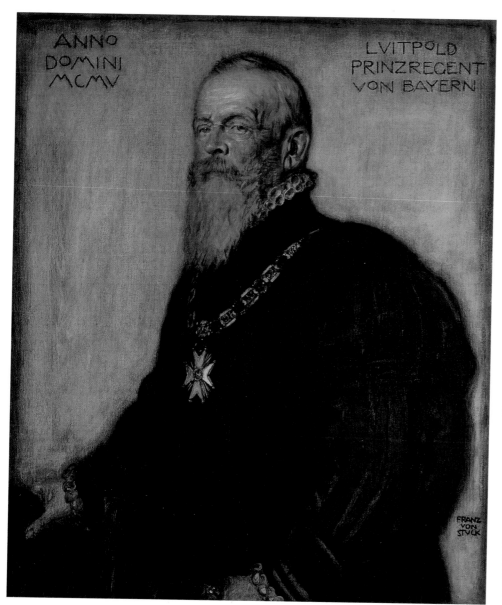

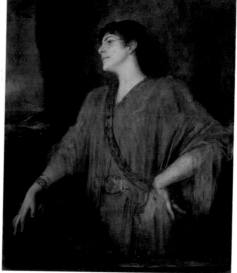

Edward Burne-Jones and James Abbott McNeill Whistler, along with French salon painters and occasionally Impressionists, whose influence on Stuck can easily be recognized.

Munich, possessing no notable industries, lived from its reputation as a city of art. Art and artists traditionally stood under the patronage of the royal family, and were financially supported by its purchases. In the year following the founding of the Munich Secession, Stuck was commissioned to paint a portrait of Bavarian Crown Prince Regent Luitpold (ill. p.9). The Secession had split the Munich art world into two opposing camps. The conservative Society of Visual Artists (*Künstlergenossenschaft*) put on mass exhibitions at the Crystal Palace, reducing the proportion of foreign artists shown. The Secessionists, on the other hand, did not eschew comparison with foreign exponents of modern art. They also promoted their cause very effectively: "Prestigious Munich exhibitions must be elite exhibitions!"

Once again Munich had rescued its reputation as a city of art, and the fame of Stuck was an indication of its innovative strength. One contemporary witness, Thomas Mann, in the novella *Gladius Dei*, ironically described the position that art and artists – and he was unmistakably referring to Lenbach and Stuck – occupied in Munich at the time: "Art blossoms, art reigns, art extends its rose-covered sceptre over the city, and smiles. A ubiquitous, industrious

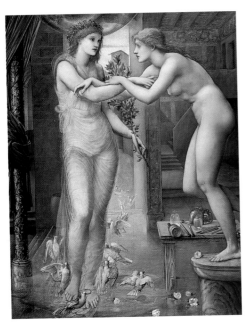

Sir Edward Burne-Jones
Pygmalion and the Image –
The Godhead Fires, 1869–79
Oil on canvas, 97.5 x 73.7 cm
Birmingham, City Museum and Art Gallery
Burne-Jones was often exhibited in the
Crystal Palace in Munich. Stuck also treated
the Pygmalion theme. While Burne-Jones
emphasizes symbolic aspects through fine
detail, Stuck reduces detail to a minimum. His
plastic handling of this subject points towards
his activities as a sculptor. Indeed, the
sculptural characteristics of many of his
paintings gave some of his contemporaries the
idea that the sculptor in Stuck might endanger
the painter.

ILLUSTRATION PAGE 11:
Pygmalion, 1926
Oil on canvas, 60.1 x 50.3 cm
Estate of the artist

participation in its prospering; dedicated exercise and promotion of its services;
a whole-hearted cult of line, decoration, form, senses and beauty reigns – Munich
shone."

Franz von Lenbach was another painter whom Stuck took as a model, along
with Böcklin, sharing his idea of the artist's calling. Lenbach, a representative
of the conservative wing of Munich artists, was a portrait painter with a reputa-
tion throughout Europe and North America (ill. p.9). He lived in Munich in a
villa which had been constructed according to his historicist ideas. Stuck, as
Munich's last "prince of art", was Lenbach's successor. In 1897–98 he built a
prestigious home which included a magnificent studio. There the artist dis-
played his many-sided talents to the full, exhibiting his own sculptures and re-
liefs and furnishings and decoration of his own design. He took his overall sty-
listic bearings from antiquity rather than the Renaissance, which was so much
in vogue at the time, and the *mise-en-scène* in which he constantly portrayed
himself, his wife and his daughter.

Stuck was a corresponding member of academies and artists' organizations
both in Germany and abroad – in Vienna, Paris and Milan among other cities.
At the World's Fair in Chicago in 1893 his paintings were awarded a gold
medal, as was his furniture in Paris in 1900. His commissions came primarily
from the aristocracy and the wealthy bourgeoisie, while reproductions of his
most famous works adorned the homes of the lower middle class. The revolu-
tionary young artist had become an established figure.

In Stuck's earliest work the foundations of all his subsequent work were to
be seen. The subject matter he then chose returned again and again, with
particular preferences at specific times in his career. In his last period, for
example, the figure of Pan largely displaced the *femme fatale*. Stuck consis-
tently pursued the aesthetic tasks he had chosen at the outset – questions of
composition, coloration, and the representation of the human figure, the last
being central to his work, as well as the creative process itself, which for Stuck
included nude and photographic studies. Around 1895 he had found his own,
very distinctive style, characterized by simplified, strongly linear composition,
concentration on large forms and stylized line.

Stuck treated his subjects in different ways, in both flat and plastic styles.
Sometimes his work was decorative, almost abstract; sometimes, where colour
was to the fore, *chiaroscuro* effects detached a central figure sculpturally from
its background. Indeed, the sculptural qualities of many of his paintings gave
rise to the idea in the minds of contemporaries that the sculptor in Stuck might
endanger the painter. However, despite the many connections between his
painting and his sculptural work, which became more important after the turn
of the century, his painting remained very much painting in its own right.

When, in the first years of the new century, French Impressionism began to
set the tone in Germany, Stuck's work increasingly came under attack. Up to
the year 1920, however, his adherence to subjects and artistic principles that
seemed outmoded did not deter students from enrolling in his painting class.
The Bauhaus master Josef Albers, for example, was one of his last important
pupils. Stuck died in Munich in 1928, honoured but almost forgotten as an
artist.

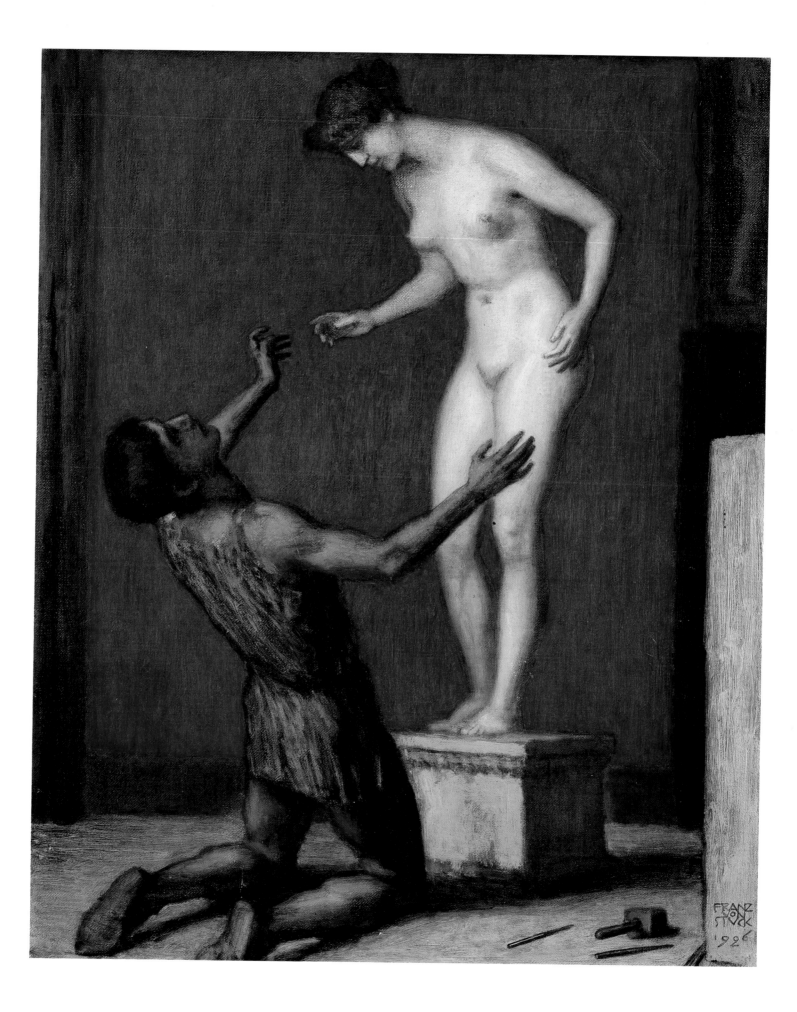

The Road to Success

Franz von Stuck had already made a name for himself as an illustrator while he was a student, long before he came to prominence as a painter. From 1882 to 1884 he designed a number of pages for a pattern-book entitled *Allegories and Emblems* (*Allegorien und Embleme*; ills. pp.13 and 16), intended for an English and French as well as German market, for the Viennese publishers Gerlach and Schenk. Beside teachers of the Munich Academy, Ferdinand Keller, Max Klinger and Gustav Klimt also contributed to this volume.

In 1886 Stuck provided 52 drawings for another pattern-book, *Cards and Vignettes* (*Karten und Vignetten*), also published by Gerlach and Schenk. Stuck's work for both these volumes displayed fantastic subjects of a kind that he was to employ repeatedly: sprites and fauns, centaurs and other fabulous beings from classical mythology, skilfully combined with ornamental designs in neo-Renaissance style. Stuck succeeded in breaking away from the sentimental national style of the years following the founding of the new German Empire in 1871; his designs possessed their own, very individual appeal. With his contemporaries and indeed with later generations too, Stuck stood in high regard as a draughtsman.

Stuck's friend and biographer Otto Julius Bierbaum justly commented that Stuck's early graphic work "anticipated most of the essentials of his mature artistic personality". In this respect, some of his early graphics are of especial interest, such as the ornate initials illustrative of the work of the goldsmith and the copper and wood engraver which are closely and naturally integrated into a page design (ill. p.13). Juxtaposed with the ornate lettering is a vigorously drawn portrait-format miniature depicting a centaur spurred on by a cupid, holding on high an abducted nymph. Stuck later returned to this image in detail in a number of full-sized paintings, the last of them being *Abduction of the Nymph* (1920; ill. p.81).

As a draughtsman, Stuck experimented with differing spatial relations. He divided the page area into symmetrically arranged segments that run parallel and do not touch one another. The latter decorative effect of his paintings, so praised and so denounced, is based on a two-dimensional pictorial pattern. A page of etched sketches dating from c.1888 (ill. p.14) dominated by a harp-playing nymph is another typical example of Stuck's early work. The nymph, reminiscent of Böcklin's mermaids, is flanked by head studies; between the two on the left are several lightly sketched galloping horsemen. In the right-hand margin is a Renaissance-style vase, and below this a finished head in profile, at which the nymph seems to be gazing. The division of the page into a broad middle section and two smaller side sections is anything but coincidental. Several of these motifs occur later in paintings: the galloping riders appear in *Wild Hunt* (1889; ill. p.16), whilst the profile reveals itself as a self-portrait of Stuck when it reappears in an oil painting more than a decade later.

Allegories and Emblems (*Allegorien und Embleme*), No. 164, 1888
Zincograph
Vienna, Verlag Gerlach und Schenk

Innocentia, 1889
Oil on canvas, 68 x 61 cm
Paris, Documentation Boisgirard/Marcilhac

"Innocentia
Her gaze so clear and straight, seeing so far,
A world entire in that so limpid gaze:
There Love and Pain lie resting in a dream,
And Beauty, like a breeze in springtime, ruffles
The clouds above. The slender lily stem
In her pale hand is motionless and holy.
I closed my eyes, and the selfsame scene
My soul beheld, that gaze, the very same,
So full of beauty, purity and love.
But where the lily stem had been, her arm
Now held a sleeping infant. The innocence
Of motherhood! That day it seemed to me
The world was beautiful, a place of joy."
Otto Julius Bierbaum (translation by Michael Hulse)

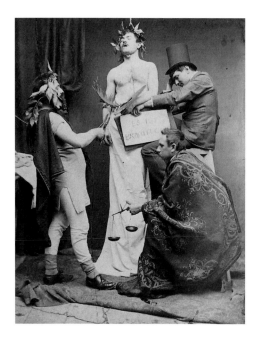

"Es ist brachtvoll!" ("It is glorious!")
Photograph
Estate of the artist
This humorous scene shows the student Stuck announcing the end of his studies with the ironic reversal of the sentence "Es ist vollbracht" ("It is completed").

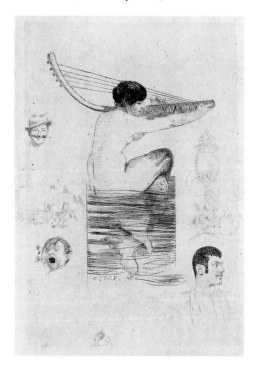

Sketch, c. 1888
Etching
Estate of the artist

ILLUSTRATION PAGE 15 TOP:
Homage to Painting, 1889
Huldigung an die Malerei
Design for a poster for the Munich Art Exhibition in the Crystal Palace
Gouache, paint and watercolour on cardboard with gold paper, laminated, 62 x 98 cm
Munich, Museum Villa Stuck

Stuck proved himself to be a brilliant caricaturist in his work for the Munich magazine *Fliegende Blätter* (*Broadsheets*) from 1887 to 1892. His targets were the Munich art scene and his own profession. Stuck's "high-spirited and satirical temperament" was also admired outside Germany, especially when he depicted local customs such as "philosophizing over beer mugs" or when he caricatured peasants and naive burghers as helpless exhibition-goers confronted with the "guests of their stalls" (cows!) or simple country girls on canvas instead of the expected "high art". A small photograph showing Stuck posing with student friends (ill. p.14) shows that these young artists did not take themselves so seriously.

The caricature *The Painting Machine* (ill. p.15) affords a penetrating insight into the flourishing Munich art industry. According to Stuck, the machine that produces paintings is "an invention of far-reaching importance". The "Painting Machine" constructed by an anonymous painter enabled its owner to order entire "galleries of old and new masters", taking into account individual wishes as to style and subject matter. In his story *Cactus – A Contribution to Modern Art History* (Kaktus - Ein Beitrag zur modernen Kunstgeschichte; 1898), Julius Bierbaum portrayed the milieu in which the invention of such a machine might be considered desirable. He describes a Munich painter who at heart has remained an "old-timer", but feels that he should conform to the "new directions" to be seen at annual exhibitions. "Thus stage by stage, but always at least a year behind the times, he becomes an Impressionist, a Pointillist, a Symbolist, a neo-Idealist, and everything that ends in -ist that one can become today if one has a palette and talent."

The imaginary Painting Machine would have become a bestseller if it had produced paintings in quantity, reliably and quickly; it would then have kept pace with the rapidly changing fashions within the art world as well as new reproduction technology. But like the latter, it would have created unemployment among many of the average artists. The industrial age had a decisive impact on art which probably constituted the most important sector of the economy in nineteenth-century Munich. The art market afforded well over a thousand painters an adequate to excellent income. Towards the end of the century it became more and more difficult for mediocre painters and those unable to adapt to the quickly changing tastes of buyers to compete with the new technology of photo-mechanical reproduction. Prints were soon affordable for everyone, allowing the least wealthy buyers to have the works of famous masters in their homes.

The Painting Machine dates from 1888 – shortly before Stuck's career as a painter began. A little later, with the founding of the Secession, Stuck himself pointed to the mass production of paintings as the cause of the decline in the quality and in the international reputation of Munich art. With his very first paintings Stuck defined his own position on the "progressive" wing of Munich artists. An 1889 exhibition poster design in subdued colours bears the characteristic title *Homage to Painting* (ill. p.15). Here, as in other works of that year, a number of thematic and aesthetic features that laid the pattern for Stuck's future success can be observed. A winged genius, a precursor of the *Guardian of Paradise*, is offering the personification of Painting a laurel wreath and a sprig of palm. The strict composition allows no overlap of persons and objects. The strength of the poster stems from an elimination of detail and the unity of colour of the background, which supplies a foil for the scene of homage.

In 1889 Stuck's oil paintings *Innocentia* (ill. p.12) and *Fighting Fauns* (ill. p.17) were exhibited in the Crystal Palace. Again Stuck used brightly coloured backgrounds consisting of opaque, thickly applied paint. *Innocentia* resembles

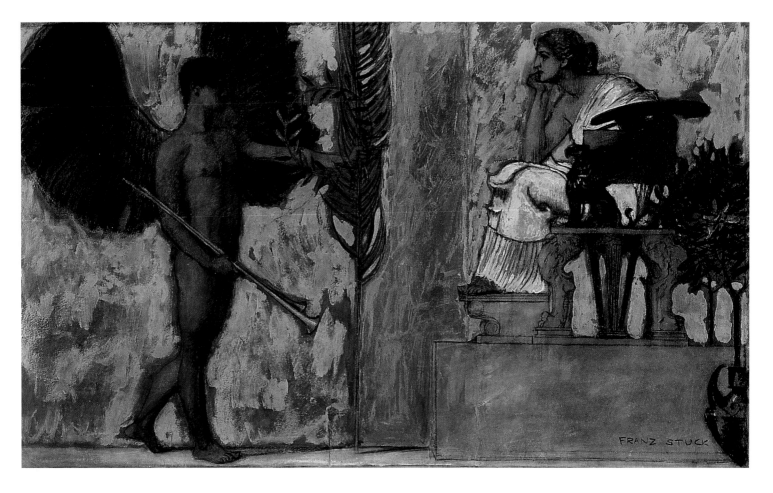

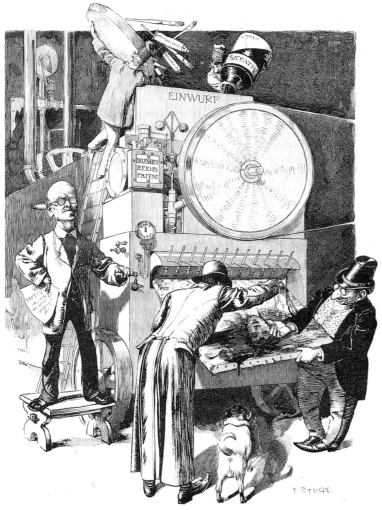

The Painting Machine, 1888
Die Malmaschine
Caricature in the journal *Fliegende Blätter*
(*Broadsheets*)
Munich, Bayerische Staatsbibliothek

"An invention of far-reaching importance has recently been patented in this city – a painting machine. The inventor is a painter – who has asked for anonymity in order to be safe from the revenge of his colleagues. The machine is able to produce paintings of any style in the shortest amount of time. In specifically pressing cases, they can be supplied while one waits. To order, it is necessary to give merely the painter's name and the subject. Portraits can be ordered by letter, telegram or telephone. The machine will supply entire galleries of old and new masters, charging by the dozen. The owner is an art dealer who purchased all rights from the inventor for 100 marks.

A distinguished art critic operates the machine, because such a man knows what makes a good picture and what the required masters must paint. New trends are excluded from the start, which means that the chief source of embarrassment for critics and public is eliminated once and for all. The public will no longer be deceived – it now knows in advance what to think about every painting. The eternal complaint of art dealers that there are no paintings available will also stop, since painters are completely superfluous now and will be used at the most to sign. In view of these shattering facts, we can only advise poor painters to take up sculpture since a machine for that – at least until now – has not been invented."
Franz Stuck

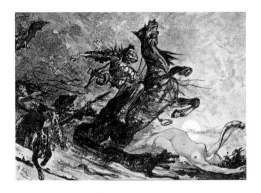

The Hunt, 1883
Die Jagd
Allegories and Emblems (Allegorien und Embleme), No. 83
Zincograph, 19.8 x 27.9 cm
Estate of the artist

Wild Hunt ("My first oil painting"), c. 1889
Wilde Jagd
Oil on wood, 53 x 84 cm
Munich, Städtische Galerie im Lenbachhaus
Stuck, renowned early in his career as a graphic artist of the first rank, turned to oil painting relatively late. He frequently took both subject matter and compositional ideas from his graphic work.

the *Guardian of Paradise* in representing an androgynous being painted in bright colours, with large, dark eyes, and is shown holding a giant lily. The painting is a paraphrase of the Christian motif of the Virgin Mary, which Stuck was to repeat a little later, much more daringly, in *Sin* (ill. p.18). There is an iconographical link with the idealized female image in the works of the Pre-Raphaelites Dante Gabriel Rossetti and Edward Burne-Jones and also the Belgian Fernand Khnopff, who painted in this tradition and like Stuck received a gold medal in 1889. The palette, however, is very reminiscent of Whistler's *Symphony in White*. Whistler exhibited many paintings in the Crystal Palace in 1888, and Burne-Jones was also a frequent guest, and medal recipient, in Munich.

There is much literary testimony to the impact made on contemporaries by paintings like *Innocentia*. Swinburne composed verses on Whistler's *Symphony in White*, Rossetti painted sonnets on the frames of his paintings, and in Munich Bierbaum dedicated a poem on *Innocentia* to the "master" Stuck (p.13). While *Innocentia* is as monumentally conceived as *The Guardian of Paradise*, in *Fighting Fauns* and *Wild Hunt* (ill. p.16) – the latter designated on the canvas by the artist as "my first oil painting" – Stuck is experimenting with colours, light and shade, and space. Here charged eroticism and the dignity of antiquity give way to head-on action. The riders in *Wild Hunt* seem to be hurtling out at the viewer, but the fauns in *Fighting Fauns* are more self-absorbed, the viewer being taken into a circle of spectators. The strict, architectural plan of Stuck's surfaces avoids overlapping. Verticals, horizontals and diagonals are emphasized according to subject-matter. Movement is played out mostly on a diagonal, as in *Fighting Fauns* and *Wild Hunt*. Along these fundamental lines Stuck steers the whole dynamic of a picture, with everything oriented in a strictly calculated direction. His compositions are based on

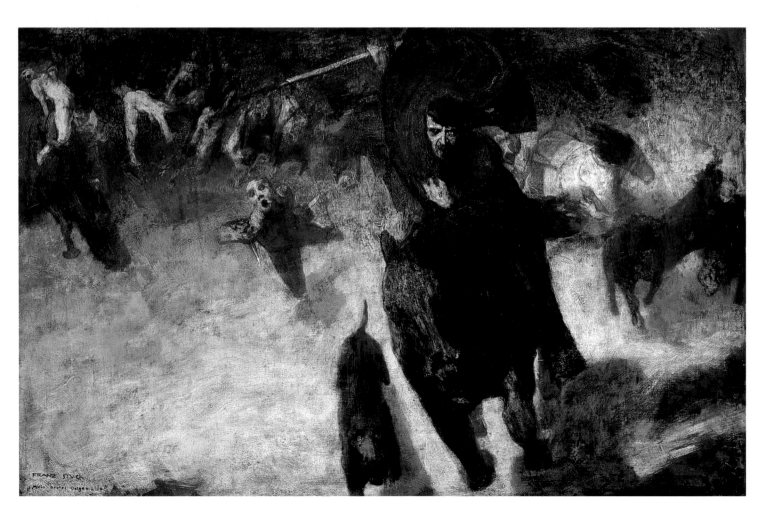

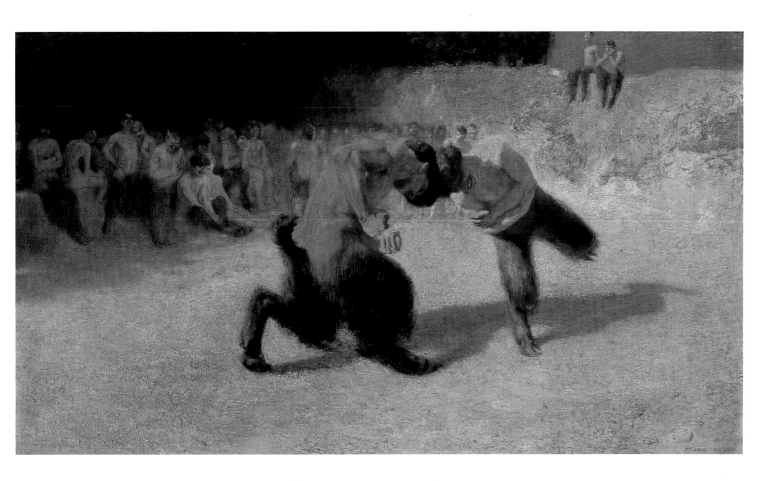

carefully drawn and also photographed studies of models (cf. pp. 50–58). Stuck's drawings display the same stylistic elements as his oil paintings, as *The Hunt* (ill. p.16) and *Steam Power* (ill. p.17) show. Here too Stuck combines what he has seen at exhibitions, for example the naked Venus lying before the shying horse in a painting by the French salon painter Alexandre Cabanel, with his own invention. *Steam Power* is not iconographically different from other industrial allegories; what is distinctive is its background divided into three vertical bands of unequal breadth: within this firm structure, *Steam Power* is held captive in the figure of a dragon tamed by a naked man.

The well-known Viennese critic Hermann Bahr, writing his *Studien zur Kritik der Moderne* (*Studies Towards a Critique of the Modern*) in 1894, commented that Stuck had helped overturn the dominance of Naturalism and Impressionism. Stuck, Bahr declared, had founded "a new style, using a mystical symbolism of primitive grandeur".

Fighting Fauns, 1889
Kämpfende Faune
Oil on canvas, 85.5 x 148.5 cm
Munich, Bayerische Staatsgemälde-
sammlungen, Neue Pinakothek

Steam Power, 1884
Die Dampfkraft
Allegories and Emblems (*Allegorien und Embleme*), No. 140
Zincograph, 28.4 x 21.4 cm
Estate of the artist

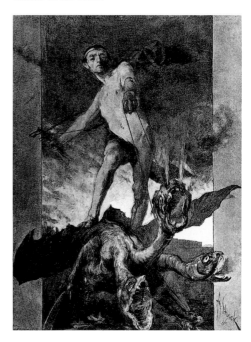

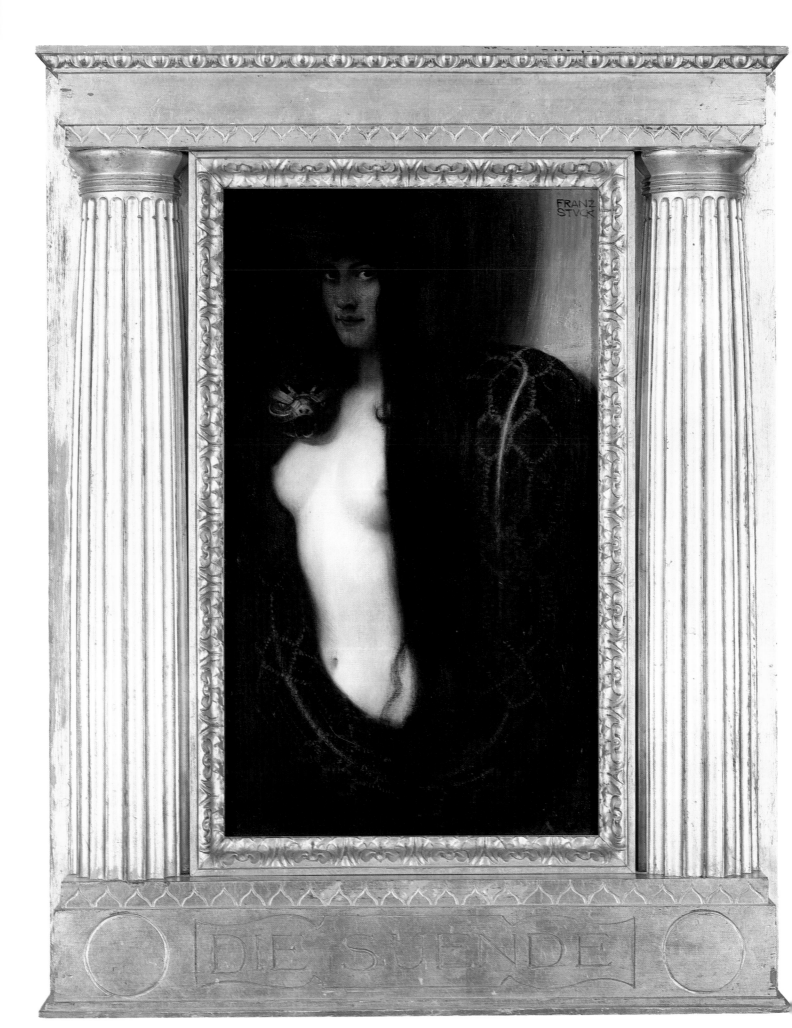

"A Woman to Drive You Insane"

In 1893, at a Secessionist exhibition in Munich, Stuck showed the painting that has perhaps had the greatest success and received the greatest attention of all his works. *Sin* (ill. p.18) depicts Eve in the sinuous coils of the serpent. Her head and naked, voluptuous upper body are slightly turned to the right; the curvature of her protruding breasts is taken up and emphasized by the long, dark hair and the heavy, strikingly patterned body of the snake, and while her body is presented to the viewer bathed in a shining light, her face is lightly shadowed. With the snake's head casually resting on her shoulder, she compels our complicity in sin with a self-assured air. The gold frame designed by Stuck for this painting, modelled on a Doric portal, elevates the painting as if it were the frame of an altar. A few years later this neo-heathen cult image became the focal point of an "altar to art" in Stuck's studio (ill. p.34). The painting was a complete success with critics and public – despite the fact that many who saw it must have felt it to be out and out provocation. Presented in a type of frame hitherto employed for religious art, the painting is a modern symbolic representation of sin. In this work Stuck not only established firm contact with the taste of his day on the surface, but penetrated the psyche of the *Zeitgeist*.

Stuck employed various means to maximize the impact of this painting. He used Lenbach's *chiaroscuro* style with the sculpturally rendered naked upper body enfolded in the flowing hair and the coiled body of the snake, a motif that appeared in Stuck's early drawings in a sketched ornamental design for a table service (ill. p.19). With her large dark eyes fixed meaningfully on us, with her alluringly glowing lips, the face of this Eve displays characteristics similar to that of *Innocentia* (ill. p.12) or of *The Guardian of Paradise* (ill. p.6), and it also has an undisguised resemblance to Stuck's own facial features.

Liberal Munich had been prepared for *Sin* and its message by "Christian erotica" in the form of cloyingly erotic representations of the Madonna. Thomas Mann, in *Gladius Dei* again, describes the work of an "unbelievably gifted fellow": "The large, reddish-brown photograph stood, framed with exquisite taste in a gold frame, on an easel in the middle of the window room. It was a Madonna, completely modern and free of any conventions. The figure of the holy mother had an oppressive femininity, bared and beautiful. Her large sultry eyes had dark edges..." The comment on this *mater amata* by male visitors to the studio left no doubt as to her less holy function: "A woman to drive you insane. The dogma of the immaculate conception is a little unsettling", or: "It is almost a portrait, but stylized to the realm of the corrupt. The small one is more harmless..."

In the "unbelievably gifted fellow" of Mann's novella Stuck is easily recognized. The picture at the centre of discussion is, however, a combination of *Sin*, *Innocentia*, and the Madonnas that were so popular in Munich at this time. In order to dispel any doubt about the real meaning of his painting, Stuck

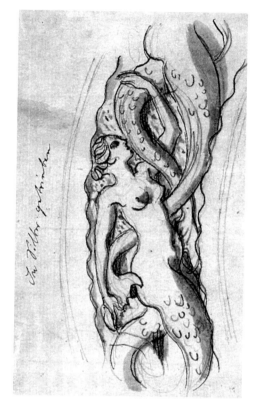

Design for a table service (detail)
c. 1885
Pencil and ink on paper, 28.5 x 45 cm
(whole sheet)
Estate of the artist

Sin, 1893
Die Sünde
Oil on canvas, 95 x 59.7 cm
Munich, Bayerische Staatsgemälde-
sammlungen, Neue Pinakothek
"The fame of the painting drove us through the galleries; we stopped nowhere and opened our eyes for the first time when we were finally standing opposite it...
There are works of art that strengthen our sense of community, and there are others that seduce us into isolation; Stuck's painting belonged to the latter group. This figure showed each man along a lonely path where sooner or later he would meet one of her living sisters." Hans Carossa, 1893

BOTTOM:
Mermaid, 1891
Meerweibchen
Oil on wood, 25 x 73 cm
Private collection
Stuck's figures are based on detailed life studies. Their transposition into a painting includes a process of stylization.

Study for *Mermaid*, c. 1891
Red chalk on paper
Estate of the artist

carved "*DIE SUENDE*" (SIN) in large letters into the base panel of the frame. The painting's statement, unlike the case in Mann's novella, is not retracted by either a historicist gilt frame or a historical framing narrative. The naked woman's body lights up in its gilt frame, making it difficult for the viewer to escape the impact of the painting. Ten years after it was painted, the art critic André Germain considered *Sin* one of the "poems about those great themes that have been nourishing mankind's songs and dreams for centuries". The Frenchman thought the painting's great success was due to its aesthetic qualities, however, to the "magic of the draughtsman and colourist". Bierbaum suspected much more profanely that the painting's success was due to "the fact that the public recognized the symbol so quickly and remembered that in certain novels a 'Ha, you snake!' was part of the indispensable repertoire of masculine outrage." Young people flocked to the Secessionist exhibition in swarms, and later to the Neue Pinakothek to see the painting that had been bought by the state. (In the following year Edvard Munch painted his equally scandalous *Madonna*.)

Sin completes the thematic cycle of Stuck's early works *The Guardian* of *Paradise*, *Innocentia* and *Lucifer* (ill. p.21). The last-mentioned painting, dating from 1890, was purchased in 1891 by the Prince of Bulgaria. As in the case of the other paintings, the suggestive power of this prince of Hades, dark and life-size, with piercing green eyes, was enormous. In the popular Munich art magazine *Die Kunst für Alle* (*Art for All*) Fritz von Ostini wrote that "the Bulgarian courtiers crossed themselves in front of this painting", as did the "Munich philistines and art magnates". Bierbaum placed the work in the context of its time and saw in *Lucifer* the figure of a furnaceman – the unstoppable and diabolic upheavals of industrialization.

Less laden with meaning are paintings like *Vice* (1894; ill. p.21) and *Mermaid* (1890; ill. p.20), both of narrow horizontal oblong format appropriate to the prone position of the figures depicted. The female figure in *Vice*, a further variation on the connection between the woman's and the snake's body, is tempting us to complicity with a seductive, knowing smile. In *Mermaid*, on the other hand, we witness a surreal scene full of "humour and wit". This painting makes it clear that from the outset Stuck based his work on nude studies of models whose features he faithfully reproduced. When the preparatory, essentially technical drawings were worked up into paintings though, these figures, and above all the heads, underwent a process of stylization that largely eliminated the individuality of the original models.

Sin made it clear that the picture frame played an important role for Stuck. He designed different types of frames to suit the nature and function of

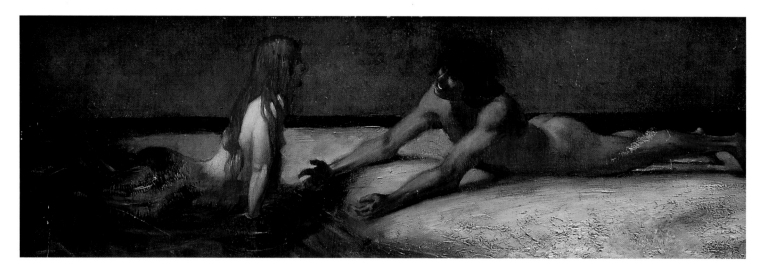

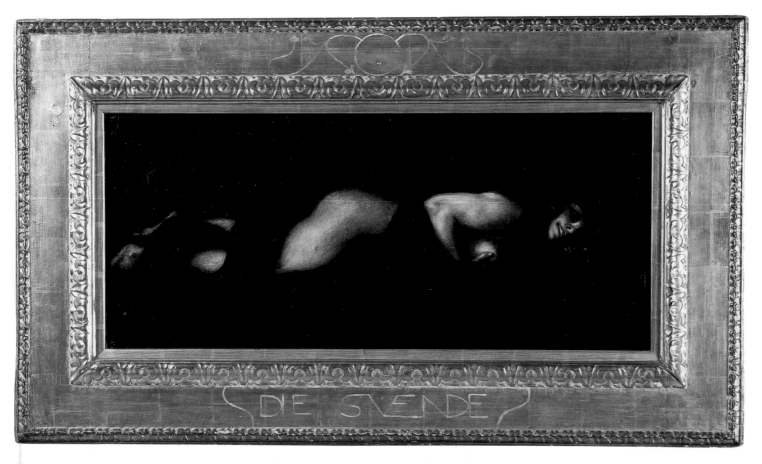

Vice ("Sin"), 1894
Das Laster ("Die Sünde")
Oil on board, 32.5 x 77 cm
Cologne, Wallraf-Richartz-Museum
Gift of Gerda and Hans-G. Neef, Cologne

Lucifer, c. 1890
Oil on canvas, 161 x 152 cm
Sofia, National Art Gallery
Lucifer shocked contemporaries as much as
Stuck's variations on the Sin motif had.
Before this demonic, lurking prince of hell
some crossed themselves, while others saw in
him the personification of the rapid and
threatening progress of industrialization.

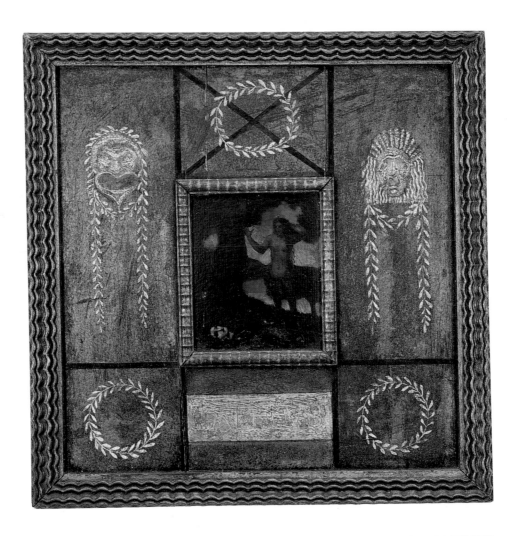

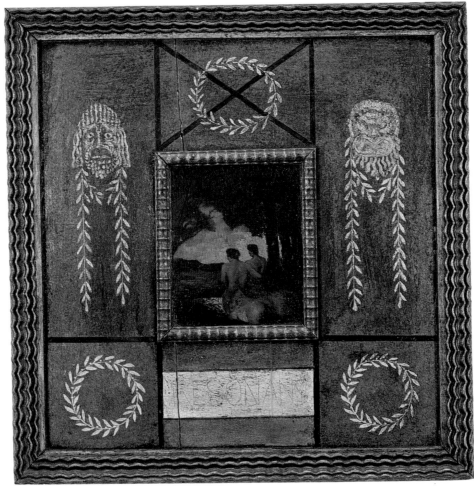

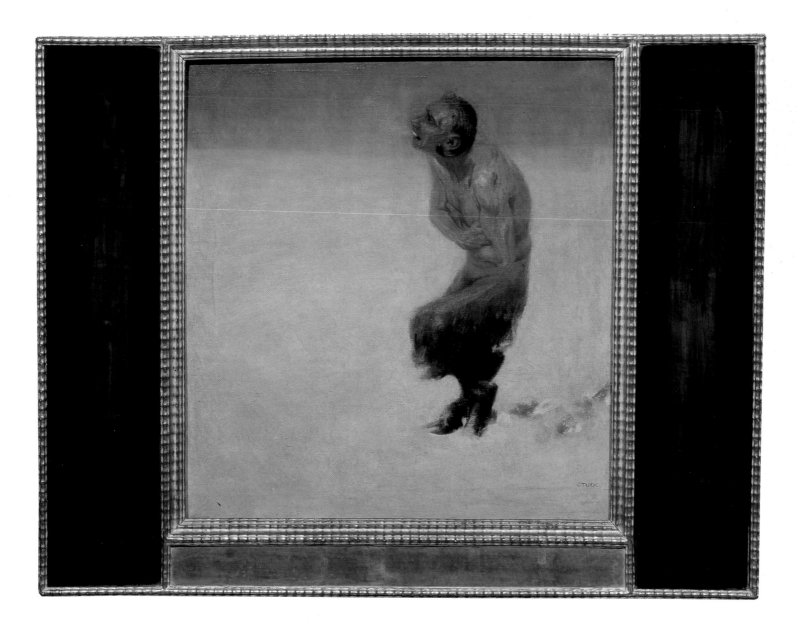

individual paintings, and they were distinctly innovative for their time. Characteristic is a multi-panel frame in which the panels, their colour suiting the painting, vary in breadth and arrangement, to emphasize the vertical or horizontal nature of the painting and extend its effects beyond the picture area. These panels, separated from each other by bevelled or wavy gilt strips, are often decoratively painted by Stuck, or bear the title of the painting, as in the case of *Sin*.

Stuck's frames have varying functions. They may simulate a wall, as in the case of *Orpheus* and *Resonance* (ills. p.22), two small-format oil paintings whose broad frames, ornamented with laurel wreaths and grotesque faces, make the pictures seem like portable mural paintings. Here, perhaps, are the origins of the wall decoration schemes at the Villa Stuck. *Orpheus* and *Resonance* are reminiscent of Ludwig von Hoffmann's idylls and conjure up a timeless arcadia. In the case of *Lost* (ill. p.23), on the other hand, as with many of Stuck's paintings, the frame is part of the work's composition, balancing out the asymmetrical structure, its broad dark fields of colour supplementing the central image done in pale tones. In view of Stuck's humour and his predilection for Italy, it is tempting to see the artist himself as the lonely freezing faun in the desolate snowy landscape.

The care with which Stuck designed and constructed his frames was often seen after the turn of the century as an indication of his decorative "arts and

Lost, 1891
Verirrt
Oil on canvas, 48 x 47 cm
Vienna, Österreichische Galerie Wien
In general Stuck designed his frames himself. He matched their appearance with the content and style of each painting and its final environment. The unity of the painting and its frame is often emphasized by the inscription of the title on the frame.

ILLUSTRATION PAGE 22 TOP:
Orpheus, c. 1891
Oil on board, 13 x 10.8 cm
Munich, private collection

ILLUSTRATION PAGE 22 BOTTOM:
Resonance, c. 1891
Resonans
Oil on cardboard, 13 x 10.8 cm
Munich, private collection

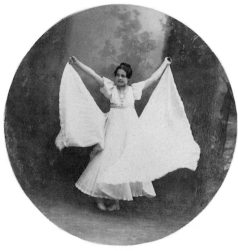

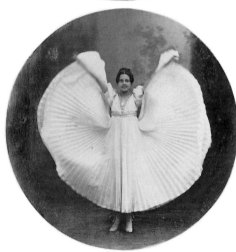

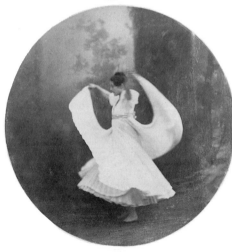

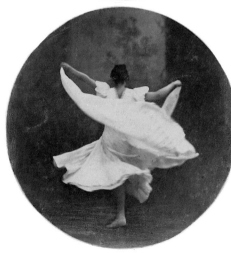

crafts" intentions, later so negatively judged by "art lovers and art critics who do not understand the most important principles of a decorative painting". The important point is that Stuck's frames are an essential constituent of either the painting or its spatial surroundings, according to their purpose; they are always a part of the total work.

Other innovative contemporaries of Stuck, whose paintings cannot be so easily dismissed as "decorative", designed frames for their paintings or for specific exhibitions, among them Arnold Böcklin, William Holman Hunt, Dante Gabriel Rossetti, James McNeill Whistler, Pierre Puvis de Chavannes, Gustave Moreau, Edgar Degas, Camille Pissarro, Georges Seurat, Vincent van Gogh, and their early twentieth-century successors, the Expressionists and Surrealists. It is thus not surprising that the Munich Secessionists attached great importance to the selection and hanging of their works, and indeed it was precisely this grasp of exhibiting potential that was seen as the really revolutionary aspect of the Secession. It was Stuck who took most care to exhibit his paintings in the most suitable frames.

The woman as menacing man-slayer, the *femme fatale* in the form of Judith or Salome or the Sphinx, makes her androgynous way through the literature and art of Europe throughout the nineteenth century. From Heinrich Heine to Otto Julius Bierbaum, from Jean Auguste Dominique Ingres to Fernand Khnopff and Stuck, writers and painters set out to penetrate her mystery. Ostini called Stuck's *Kiss of the Sphinx* (1895; ill. p.27) a "work of enormous power that realizes the antique in intensive modern dramatic terms, in the spirit of Heine's beautiful poem":

"Before the gate there lay a Sphinx –
Terror and lust cross bred!
In body and claws a lion's form,
A woman in breast and head.

A lovely woman! Her white eyes
Spoke of desire grown wild;
Her lips gave silent promises,
Her mute lips arched and smiled.

The nightingale! she sang so sweet –
I yielded, passion-tossed –
And as I kissed that lovely face,
I knew that I was lost.

The marble image came alive,
Began to moan and plead –
She drank my burning kisses up
With ravenous thirst and greed.

She drank the breath from out my breast,
She fed lust without pause;
She pressed me tight, and tore and rent
My body with her claws."
(Translation by Hal Draper,
*The Complete Poems of
Heinrich Heine*, Oxford 1982)

Stuck's large-format, almost square oil painting shows a naked young man and a sphinx, a being half woman and half big cat. The sphinx is crouching on a rock ledge which her naked upper body voluptuously overhangs. Embracing her victim, she is suffocating him with her kiss of death, her flowing, dark hair

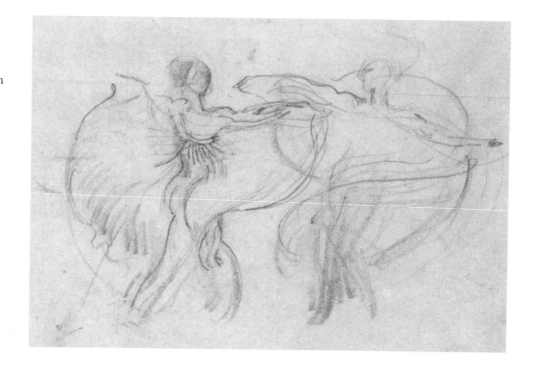

Study for *Dancers* (detail), 1895
Pencil on paper, 21.5 x 21 cm
Estate of the artist

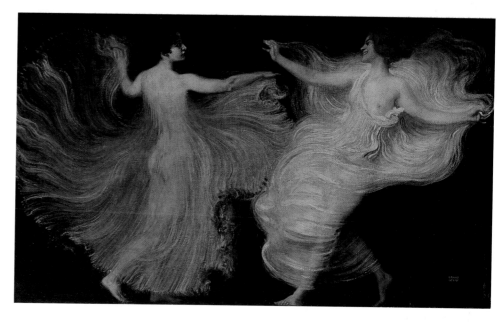

Two Dancers, 1896
Zwei Tänzerinnen
Oil on wood, 51.5 x 87 cm
Schweinfurt, Georg Schäfer Collection
Stuck used various techniques in treating the
dance motif. Here the sequence is unusual;
the relief was made first, then the sketch, and
finally the oil painting.

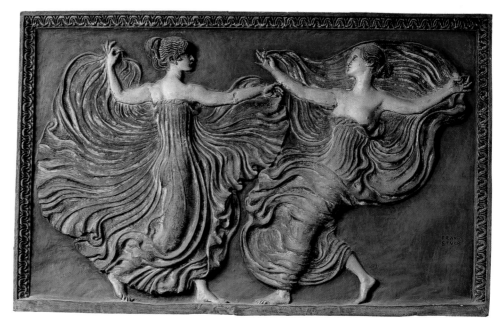

Veil Dancers, 1894/95
Serpentinen-Tänzerinnen
Painted plaster, 62 x 100 cm
Munich, Museum Villa Stuck
This relief belonged to the decorative scheme
of the walls of the music room at the Villa
Stuck, the pictures on the entire north wall
being devoted to dance.

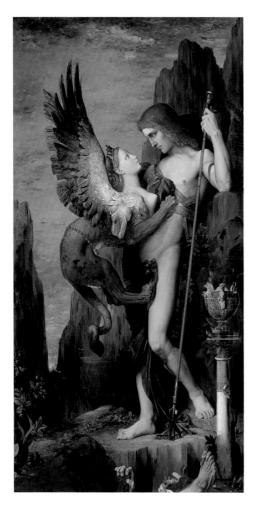

Gustave Moreau
Oedipus and the Sphinx
Oedipe et le Sphinx
Oil on canvas, 206.4 x 104.8 cm
New York, Metropolitan Museum of Art,
gift of William H. Herriman, 1921
The French Symbolist Moreau portrays
Oedipus as the self-disciplined conqueror of
the Sphinx. In Stuck's painting, by contrast,
the man neither wishes nor is able to wrest
himself from the embrace of the seductress,
as in Heinrich Heine's poem of 1839 (p.24).

caressing his body. The drama of the subject is brought out by the solid dark areas and deft *chiaroscuro*. The naked body parts are highlighted, while everything else is plunged in a darkness enriched by red, blue and yellow.

The French Symbolist Gustave Moreau, one generation older than Stuck, treated this subject completely differently. His painting *Oedipus and the Sphinx* (ill. p.26) is supposed to have been inspired by Heinrich Heine's poem of 1839 (see p.26). Oedipus's masculine rationality triumphs, whereas in Stuck's painting the man passionately sacrifices himself to the woman (the sacrifice that brings Heine's sphinx "gratification"). The display of photographs of this painting in the windows of art galleries was banned by the Munich police, which indicates that the painting was not conceived or understood as an academic reinterpretation of classical mythology for the educated classes. Compared with Stuck's great *Sphinx*, Moreau's treatment of the subject, indeed his whole painting style, seems very "civilized".

Stuck's *The Kiss of the Sphinx* may be compared with his *Self-Portrait* of the same year; the sacrificial man bears his own facial features. Furthermore, Stuck's *Self-Portrait* is extremely stylized and painted with the same dramatic light effects as *The Kiss of the Sphinx*. The artist seizes upon the viewer as the Sphinx does her victim. The idealized representation corresponds to a description given by one of Stuck's students at the Academy, Hans Purrmann, of his teacher: "His nature was closed in on itself; no smile, no empathy showed itself on his handsome face. Short, pointed nose, pursed lips, strong chin, dark brown, piercing eyes, low forehead, black hair and sallow complexion." Other contemporaries describe Stuck as taciturn, serious, solemn and secretive. Even Purrmann's description is restricted to externals, and is dominated by his respect for his teacher. Insight into his character is accorded not so much by official self-portraits and articles about Stuck as by extant photographic studies (p.58).

From this period date works that show another side of Stuck's art and nature. Like many other *fin-de-siècle* artists, he was fascinated by the aesthetic possibilities of dance. Dance appears repeatedly in his work as visible rhythm, as an allegory of spring and the joy of life. It was in handling this kind of material that Stuck further developed his decorative, planar style. His iconographical model here was post-fifth-century BC Greek art in which foreground and background were treated on the same level. It is interesting to see the dance motif developed from planar treatment to three-dimensional relief and even sculpture.

Stuck's treatment of dance in various media (ill. p.25) was based on the innovative "dance of the veils" by Loïe Fuller, who began to perform in 1892. With her body draped in colourful veils, she created the most beautiful ornamental patterns in her dancing, which inspired not only Stuck but also Henri de Toulouse-Lautrec. Stuck, however, did not take his subject matter to abstraction; his aesthetic continued to be figuratively based. Here is one reason, therefore, why it is not possible to classify Stuck as an Art Nouveau painter without qualification. In the plaster relief *Veil Dancers* (1894/95), which served as a model for a somewhat smaller painting (1896), the bodies of the dancers, turned towards each other, set the light veils they are wearing into rhythmic motion in which their individual movements complement each other. Stuck's daughter Mary, born in 1896, later took lessons in veil dancing (ill. p.24).

In treating the dance theme in different media, then, Stuck did not make studies of individual models, but deployed the same motif variously, to different artistic ends. By 1895 he had found a personal style, evolved partly from his interest in antiquity and partly from his continued exploration of different media – drawing, painting, sculpture and photography.

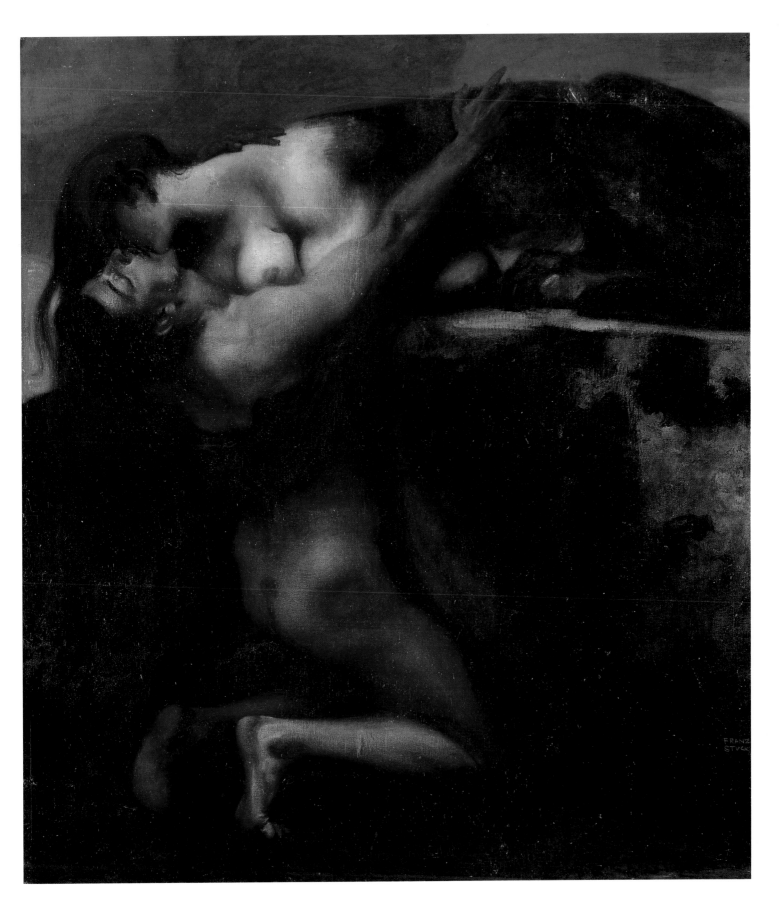

The Kiss of the Sphinx, 1895
Der Kuß der Sphinx
Oil on canvas, 160 x 144.8 cm
Budapest, Szepmüveszeti Muzeum

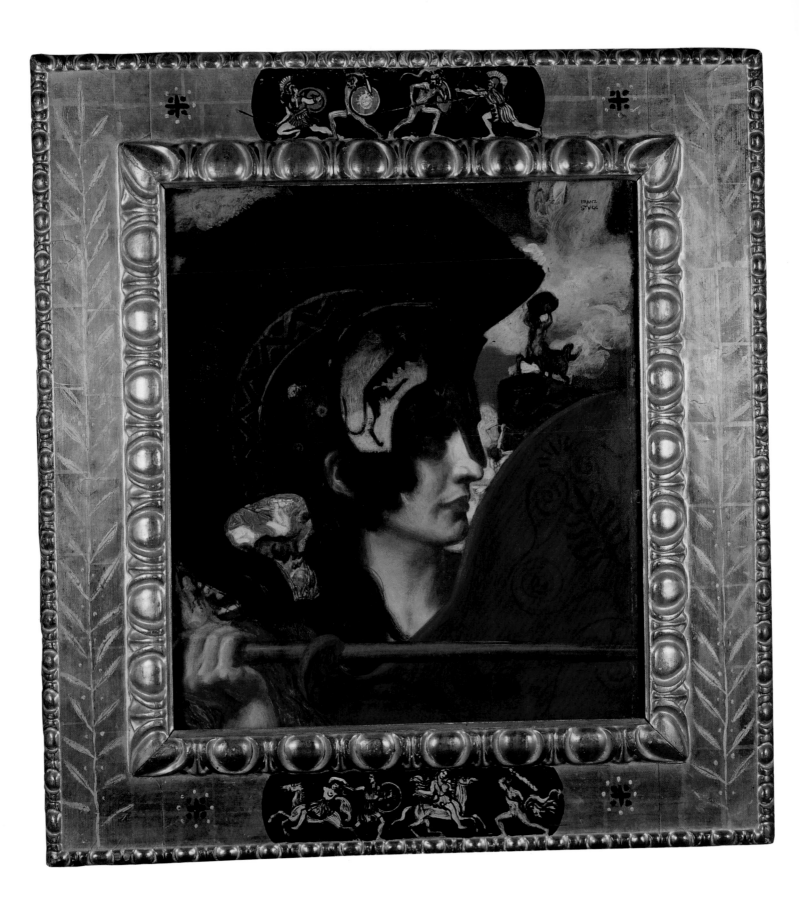

The Prince of Art

The year 1897 was an eventful one for Franz Stuck. He married an American widow, Mary Lindpainter, and the couple later adopted his illegitimate daughter Mary, whom he had fathered with Anna Maria Brandmeier. In 1897–98 Stuck designed and built a much admired residence, the Villa Stuck which also housed his studio; it not only defined his place in society and won him his battle for recognition, but it also placed him on a level with the most celebrated "princes of art".

Stuck was meanwhile cultivating a friendly relationship with Lenbach, the president of the Munich Society of Visual Artists. In 1897 the Society of Visual Artists and the Secession jointly organized the Seventh International Art Exhibition at the Crystal Palace. Stuck showed the painting *Fighting Amazon* (1897; ill. p.28) among other works. An Amazon's face in profile dominates the almost square format. The head is largely covered by a helmet painted with a classical zig-zag motif. The right hand, holding a spear, is raised to shoulder height; her invisible left holds a curved shield. In the corners are two small combat scenes in the manner of Böcklin: at top right a centaur is throwing a rock from a precipice at an Amazon drawing her bow, while at bottom left an Amazon is riding down a centaur. The foreground is closely linked to the background in an overall colour scheme, the large expanses of red, black and blue being relieved by lighter areas. The sumptuous broad gilt frame intensifies the luminous quality of the colour in the painting. The figurative piece of frieze with fighting warriors and Amazons painted on the frame at top and bottom reinforces the content of the painting.

There is a formal link with Stuck's earlier depictions of Pallas Athene, among them the famous Secessionist poster of 1893 (pp.29 and 86). The motifs of both works are traceable throughout to Greek models such as the Aeginetan frieze in King Ludwig I's collection of antiquities now in the Munich Glyptothek, or Attic vase painting.

Bierbaum did not rate *Fighting Amazon* especially highly, seeing it as simply "a brilliant piece of decoration" without poetic value. He failed to recognize that the work summed up Stuck's aesthetic ideas, restating them with special reference to his mentor, Arnold Böcklin. Böcklin's seventieth birthday was celebrated in 1897 with retrospectives and great honours for the painter. The small combat scenes in *Fighting Amazon* allude to the Basle master's work in homage. Even the medium, tempera and oil on wood, is an echo of Böcklin's technique; and the brushwork is flat and fluid, with nothing to remind us of the impasto brushstrokes of Stuck's early work. With his starting-point as their shared model of antiquity, Stuck transposed Böcklin's compositional principle that "an artwork is simply contrast" into a two-dimensional pattern of colour and *chiaroscuro* contrasts, thus sharply differentiating his approach from Böcklin's. What is probably his best known sculpture, *Spear-throwing Amazon*

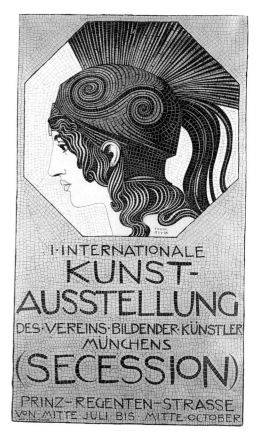

Poster for the First International Art Exhibition of the Munich Secession, 1893
Lithograph on paper, 61.5 x 36.5 cm
Munich, Münchner Stadtmuseum, Graphiksammlung
Stuck's poster with its profile of Pallas Athene remained the symbol of the Munich Secession up to the 1930s.

Fighting Amazon, 1897
Kämpfende Amazone
Oil and tempera on wood, 50 x 44 cm
Munich, Städtische Galerie im Lenbachhaus

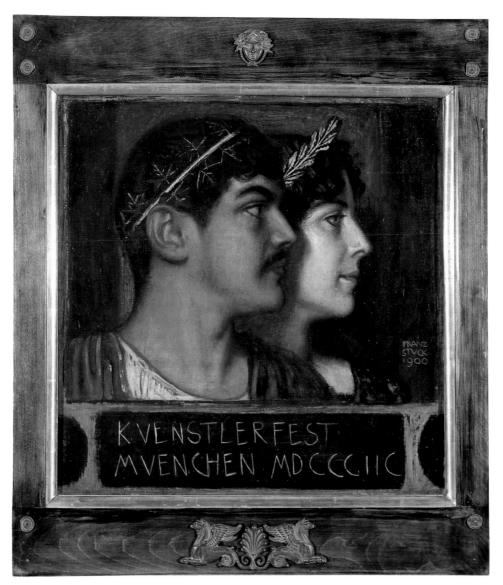

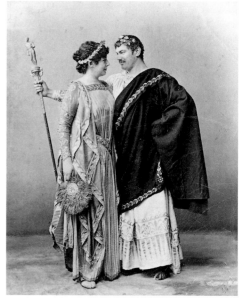

(ill. p.66), dating a few months later than *Fighting Amazon*, is far more naturalistic than the near-abstract painting.

Fighting Amazon embodied a programme in opposition to the "old" Munich school. The "modern Hellenist" turned against the Renaissance model, which had governed painting and above all crafts till that time. Stuck's strong colour contrasts and bold lines broke away from dark, "old master" tones. A craft interest was strong in Stuck; he designed new types of frame and with his exhibition posters introduced new aesthetic energy to graphic design. His poster for the International Art Exhibition (pp.29 and 86) shows a stylized profile of *Pallas Athene*.

In 1898 Stuck reworked his theme in Pallas Athene (ill. p.31), a half-length painting in which the face and arms are three-dimensionally modelled and individualized to the extent that the facial features of his wife can be recognized. Her helmet and armour, on the other hand, are integrated with the monochrome background. In this work we see a new principle coming into play: Stuck gives a painting monumentality by emphasizing sculptural elements. The subject is based on an antique sculpture of Pallas Athene in the possession of Stuck. This portrait of the patron goddess of the fine arts, is set off by a sumptuous gilt frame designed by himself. Stuck's procedure here is different from that in *Sin*: rather than working from a sculptural model, he cites purely decorative, neo-Classical architectural features. Here too the title of the painting is

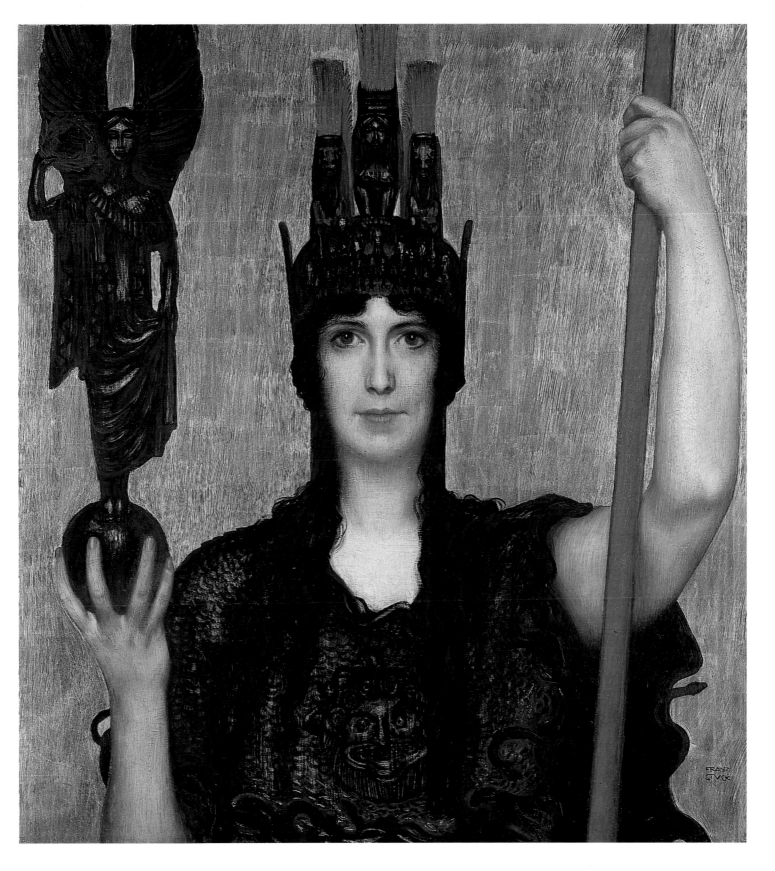

Pallas Athene, 1898
Oil on wood, 77 x 69.5 cm
Schweinfurt, Georg Schäfer Collection
The patron goddess of ancient Athens and of the fine arts is portrayed with the stylized
facial features of Mary Stuck.
The classical model replaces that of the Renaissance.

carved in the base of the frame. To quote Bierbaum once more, everything in the painting "stretches steeply upward", in almost parallel lines; in short, here is a symbol of the "towering goddess".

In 1898 an artists' festival with the title "In Arcadia" took place, in which the entire Munich artist community took part. At the masked ball a costume from antiquity was prescribed, and Franz and Mary Stuck appeared as the ruling gods Zeus and Hera (ill. p.30). It was the first time antiquity had been taken as the theme for an artists' festival in Munich. It was more than just a carnival whim. Bierbaum ascribed a serious motive to the masquerade: "We have in this artist dressed as a figure from antiquity, with a profile from a Roman bronze, the artistic spirit of antiquity." From now onwards constant reference was to be made to Stuck's "Roman nature", his "strong" and "healthy" physical constitution. The young "prince of art" was made for the cult of genius that flourished in the closing years of the nineteenth century. He represented both in his work and in his person an ideal counter-image to his era, which was one of great social and economic change.

Stuck had become sufficiently wealthy, and artistically resourceful, to be able to construct his own arcadia as a *Gesamtkunstwerk*. His house, which Ostini called "the great masterpiece of a powerful talent", was built on the Isar heights on Prinzregentenstrasse on a prominent site (ill. p.33). Stuck, who had been thoroughly trained at the Munich Arts and Crafts School, designed the villa from the first plans to the wall decorations and furniture. Probably under the inspiration of Arnold Böcklin's popular series of paintings *Isles of the Dead* (ill. p.32), his plan included tall cypresses that atmospherically framed the structure.

Stuck's villa was constructed by the Munich-based firm of Heilmann and Littmann; it gave the artist a stately public presence in the style of neo-Classicism, which had bestowed on Munich an impressive and majestic architectural legacy since the beginning of the century. The façade facing the street has a pronounced threefold horizontal and vertical division: the middle section is recessed slightly from the two wings. The large storey-height windows also have threefold division, harmonizing with the flat façade; above and below them are three classical reliefs. No superfluous sculptural ornamentation diminishes the monumental impact of the façade, whose design reflects the hierarchy of the rooms, centred on Stuck's studio on the first floor.

A Doric portico, similar in form to that of the frame of *Sin*, extends from the flat, geometrical façade. It reaches up to the first floor, where it is surmounted by a balcony behind which Stuck's studio is situated. The entrance to the villa is by a bronze door under the portico. The interior of the villa is a meticulously planned decorative and spatial sequence. The visitor passes through the vestibule, decorated with antique reliefs and sculptures, to the reception rooms. The music room, its decorative painting entirely by Stuck, is particularly interesting. Illusionistic wall-paintings, based on a Pompeian model, are topped by the starry heavens (ill. p.35 top right), which are traversed by a comet – Stuck? Stuck's works are repeated as murals in strict accordance with the subdivision of the walls. On the northern wall is *Two Dancers*, variations on which are seen on either side, grouped around Pan playing the flute; on the southern wall stands Orpheus as the centre of the world of song (ill. p.35 top left and bottom).

The stylistic characteristics of Stuck's paintings were restated in three dimensions in the building and decoration of the Villa Stuck. The artist himself took total personal control of the project. His studio is the spatial as well as conceptual centre of the building. The large, long room is the only one opening

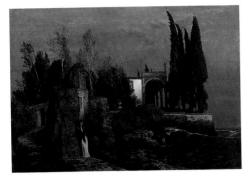

Arnold Böcklin
Villa by the Sea, 1877
Villa am Meer
Oil on canvas, 108 x 156 cm
Stuttgart, Staatsgalerie Stuttgart
The series "Isles of the Dead" to which this painting belongs was one of the most popular of Böcklin's pictorial inventions. Stuck transformed this symbolic, architectural vision into reality with the construction of his Munich Villa.

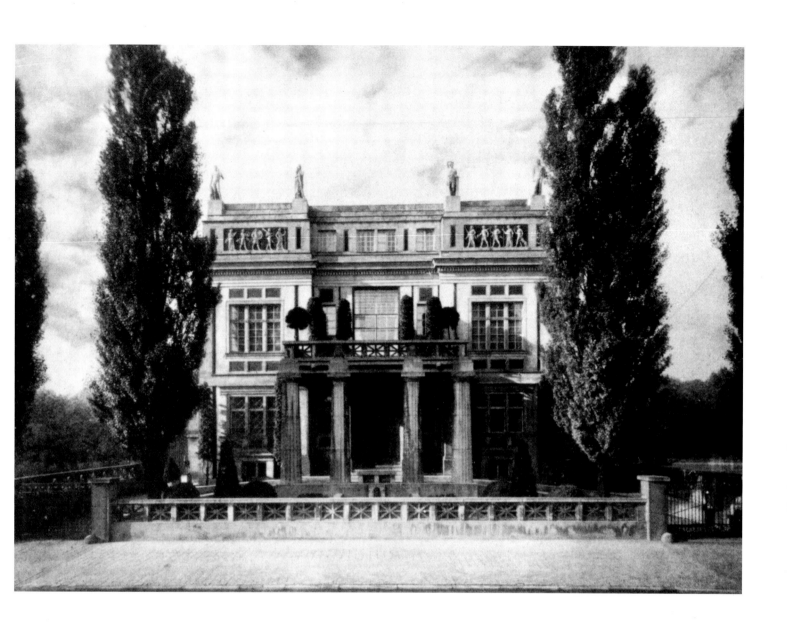

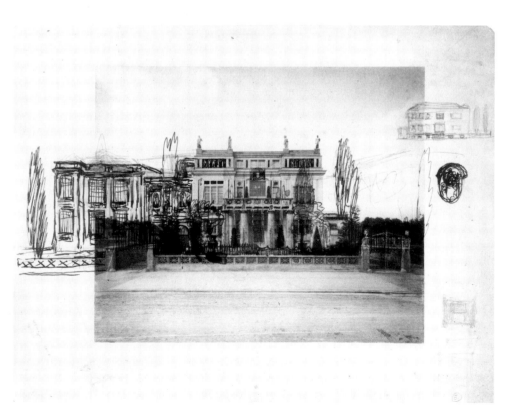

Villa Stuck, 1899
Retouched photographic montage
On a photograph of his nearly completed
Villa, Stuck superimposes tall poplars
framing the building to left and right,
intended to evoke ideas of continuity and
dignity in this *Gesamtkunstwerk*.

Photograph of the Villa Stuck in 1898 with
Stuck's inked sketchings for the addition of
a studio
Estate of the artist

33

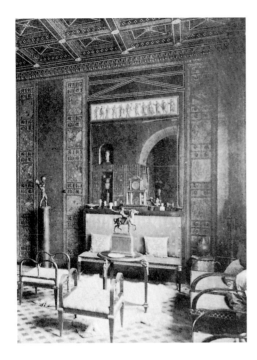

Reception room in the Villa Stuck, c. 1900
Photograph
Stuck designed the entire interior furnishings
and decoration of his Villa. The furniture
was awarded a gold medal at the Paris
International Exposition of 1900.

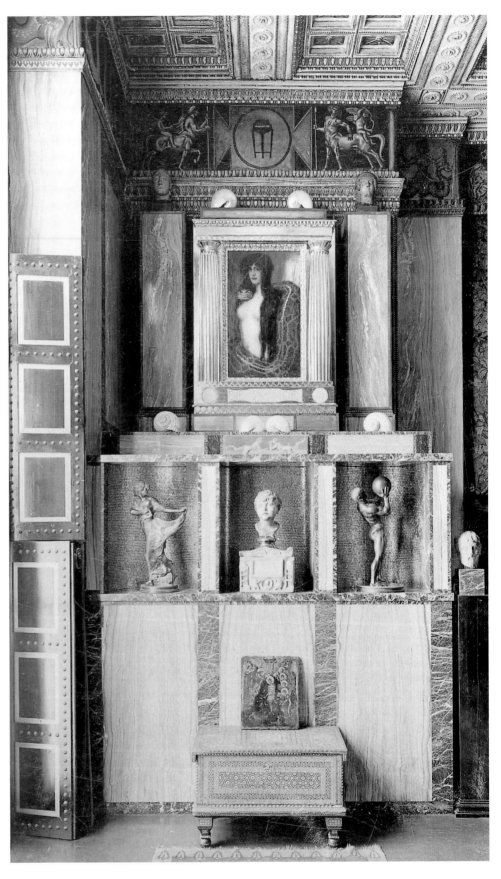

The Altar to Art (*Sin*), c. 1900
Photograph
Munich, Museum Villa Stuck
"The main colouristic impression of the room is made by the remarkable aedicule-like feature
which the artist has built next to the window in full light and decorated to give a magical effect
of sparkle and colour. This creation, even if it affects the senses of a normal person like a seven-
tailed whip, must act as a first-class tonic for modern eyes so easily brought to a dangerous
hypersensibility through mollycoddling of colour." Georg Habich, 1899

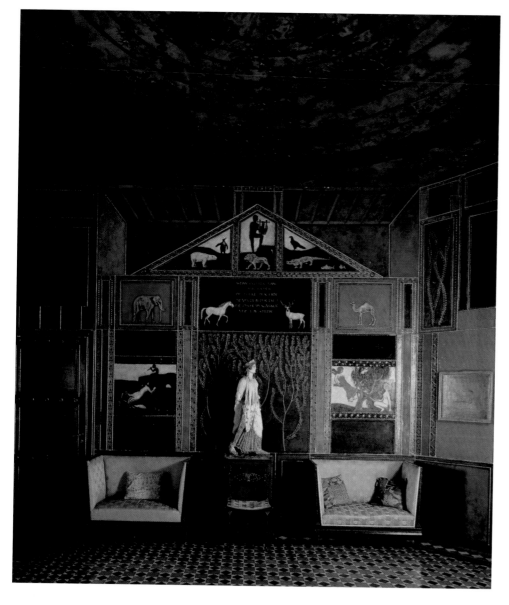

The Starry Heavens
Sternenhimmel
Ceiling painting in the music room of the
Villa Stuck
Photograph

Music room of the Villa Stuck: southern wall
with ***Orpheus*** and the world of song
Photograph

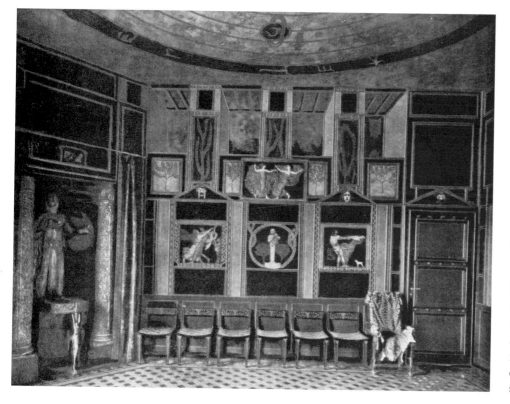

Music room of the Villa Stuck: northern wall
with ***Pan*** at the lower centre symbolizing
dance
Photograph
The artistic plan of the music room is based
on a carefully thought-out pictorial and
decorative scheme. Dance and song,
represented by Orpheus and Pan, hold the
centre. The room is spanned by a painted
starry sky.

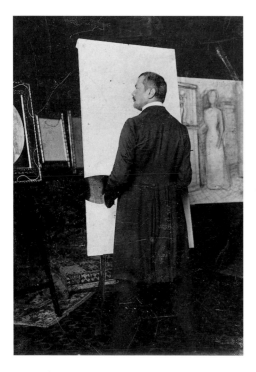

Photographic study of Franz von Stuck at
his easel, 1902
Photograph
Estate of the artist

Photographic study of Mary Stuck with
tracing marks, c. 1900
Photograph
Munich, Ziersch Collection
In many cases Stuck's paintings begin with
photographic studies. Stuck here photographs
himself in front of his canvas in the position
to be adopted in the double portrait shown
opposite; on his right is a preliminary sketch
of the painting. Photographic studies would
sometimes be enlarged and traced directly
onto the canvas.

onto the balcony over the front entrance to the house, where the painter could
hold court. In the centre of the studio, near the windows, is the "altar to art"
(ill. p.34), constructed for the purpose of displaying Stuck's major works (and
at the same time serving the more down-to-earth purpose of providing a place
for Stuck's models to change). With the exception of the architect and designer
Henri van de Velde, who visited Stuck around the turn of the century, Stuck's
contemporaries were deeply impressed by his studio. Van de Velde, saw no
advance over the Villa Lenbach, only "false, tasteless luxury" based on tricks
played with materials: "The sumptuous wall and ceiling panelling seemed to be
made of costly wood, but in reality they were only plaster."

An interesting double portrait, *Franz and Mary Stuck in the Studio* (ill. p.37),
dates from 1902. Stuck is standing on the right-hand side of the painting, his
back and profiled face like a silhouette in front of the still unpainted canvas.
He is wearing a dark frock-coat and seems to be pointing his palette proudly
towards the resplendant Mary, who is wearing a light evening gown. On the
left next to Mary the altar to art is partially visible, displaying the small sculp-
ture *Athlete*. Behind her on the right is *Two Dancers* in a relief form, and on the
left of her the red chair designed by Stuck in 1898. The costly, elegant furniture
that Stuck designed for his residence around 1898 was awarded a gold medal at
the Paris International Exposition of 1900. More than those pieces, based on
ancient Egyptian models, this red chair with its strikingly right-angled design
and complete lack of added ornament and secondary features can be seen as
thoroughly modern.

Such lavish self-presentation demanded its price. Stuck painted society
portraits in order to support the upkeep of the Villa. Here he had to compete
with Lenbach, the undisputed master of the psychologically sophisticated
portraits. Stuck's best portraits are not his commissions, but what Ostini called
his "picturesque" portraits, such as *Lady in Red* (ill. p.38) or the portrait of his
favourite model Frau Feez (ill. p.39). Like Lenbach, Stuck photographs his
portrait work. But unlike his rival, Stuck frequently so stylized his line in

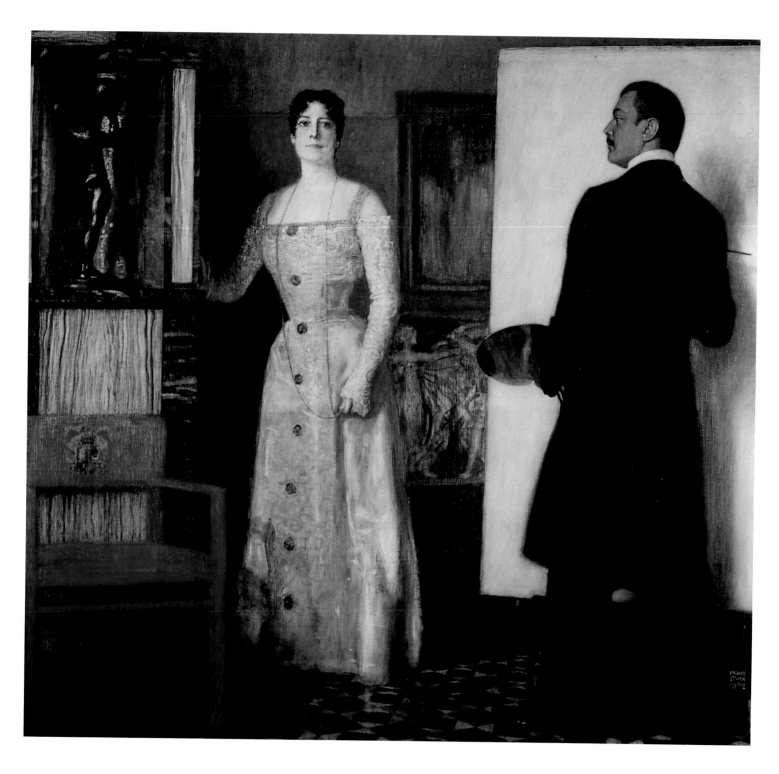

Franz and Mary Stuck in the Studio, 1902
Franz und Mary Stuck im Atelier
Oil on canvas, 57.7 x 51.2 cm
Private collection

Lady in Red, c. 1900
Dame in Rot
Oil on canvas, 60.5 x 50 cm
Estate of the artist
Stuck's portraits were controversial among his contemporaries. Even a friend commented:
"There is something superficial about Stuck's portraits. They never lack charm of line and a
powerful effect of colour, gesture, tone, and overall impression, but that magic that we feel,
for example, in a Lenbach portrait is absent. They are pretty paintings that express
everything that the artist found interesting in a face, but they are not profound statements
about the nature of the person portrayed."

Portrait of Frau Feez, 1900
Bildnis Frau Feez
Oil on canvas, 50 x 45.2 cm
Estate of the artist
Frau Feez was Stuck's favourite model. This sympathetic and
intimate portrait is one of the few in which the subject does not take
on a different identity. Her personality is apparent here. The double
frame, constructed with special care, gives the painting an eloquent
ornamental and decorative effect.

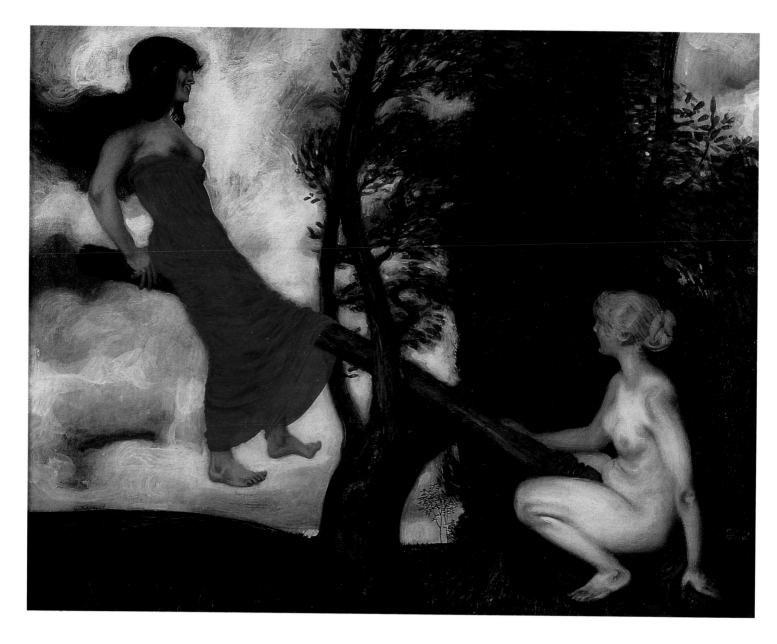

The Seesaw, 1898
Die Wippe
Oil on canvas, 59 x 75.5 cm
Munich, Museum Villa Stuck
Stuck's contemporaries did not respond to the overtly erotic. Like Otto Julius Bierbaum, they attached significance to the compositional elements and characterized this painting as a "balanced play of line and colours".

tracing that the finished portraits, according to Schmoll, called Eisenwerth, "because of their ornamental character, were completely different from their photographic originals".

Stuck, who was seen by his contemporaries as a figure painter, took an interest in landscape only in his early years. Even in the virtuoso, atmospheric *Seaside Sunset* (1900; ill. p.41 bottom), the focus is not on landscape but on man, even if only to a modest degree. In other paintings, trees, sky and earth are present merely to indicate a location in nature and are often summarily rendered. In *The Seesaw* (1898; ill. p.40) nature ad mankind are in rare balance of emphasis. This small oil in which, according to Bierbaum, "Stuck is no less great than in his grander works," was a special favourite of the artist's contemporaries – whether because of "the play of line and colour," or because of the erotic appeal that now seems so slight, it is hard to say.

Stuck loved to place human beings and animals in contact with each other, from the innocuous boy in *Boy Bacchus Riding on a Panther* (ill. p.41 top) to the flower-bedecked nude girls in a spring landscape swaying on the back of a fabulous beast (depicted as a wild animal behind, a good-natured man in front) to the rhythm of a Pan flute in *The Ride* (ill. p.42). His contemporaries loved the "three Hellenic teenage girls taking the accommodating centaur for a ride with true feminine cunning". *The Ride* and other similar paintings were also

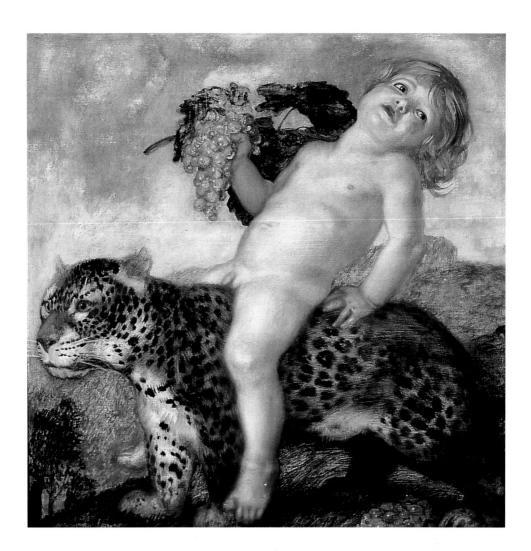

Boy Bacchus Riding on a Panther, c. 1901
Bacchusknabe auf einem Panther reitend
Oil on wood, 69.3 x 69.9 cm
Private collection

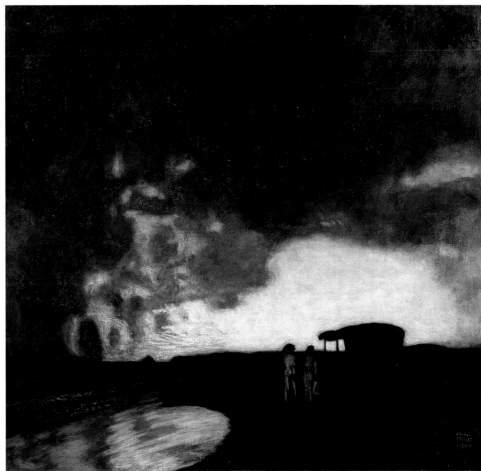

Seaside Sunset, 1900
Sonnenuntergang am Meer
Oil on canvas, 71 x 73.8 cm
Private collection (Munich, Galerie Ritthaler)
Only in Stuck's early work do landscapes
play any larger role. The human figure is
generally a compositional focus, and in this
painting the purpose of the dramatic evening
landscape is to make an emotional impact on
the human heart, both those of the figures in
the painting and that of the viewer.

acclaimed outside Germany. Stuck had created unconventional interpretations of figures from Greek mythology and had thus invested them with new life.

The sphinx returns in 1904 (ill. p.43), not as a creature half woman, half cat, but as a provocative, cool society lady. Stuck had treated the myth of the sphinx many times before the turn of the century. A first version in his early period depicts a beast lying on a high cliff, a combination of animal and androgynous human figure. In a second painting Stuck juxtaposes a sphinx with its conqueror Oedipus. In a third, *Kiss of the Sphinx* (ill. p.27), he equates passion and death. Contemporaries were as much annoyed by as attracted to his interpretation of 1901 and its repetition of 1904. Fritz von Ostini commented on the latter that it was a "strange version of a much depicted subject in which the fabled creature appears simply as a naked woman lying watching on her stomach supported by her elbows. The cat's body is not there at all, and still the creature is 'completely a cat' in expression and attitude, false and beautiful, flattering and dangerous. The name of this sphinx is – Woman!" She is lying in wait in a heroic landscape, frozen like a sculpture, for her victim. The 1901 work illustrates the mystery of the sphinx written out on the base of the frame; in the second a marble plinth is suggested on which the title of the painting is carved. The deliberately naturalistic portrayal gives the mythological creature a real presence as a society lady, and hence a certain surrealistic attraction. For Stuck and other artists of his day, the sphinx was the ultimate incarnation of mysterious and dangerous femininity. The sphinx-like nature of woman, the incalculable *femme fatale*, was to occupy Stuck right until the end of his creative life.

Whether in the guise of centaurs, primitive men, or even his seemingly civilized contemporaries, the battle of the sexes was for Stuck one of the laws

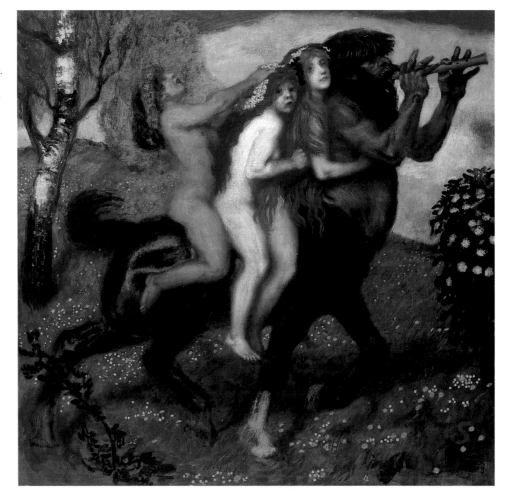

The Ride, 1903
Spazierritt
Oil on canvas, 67.5 x 69 cm
Schweinfurt, Georg Schäfer Collection

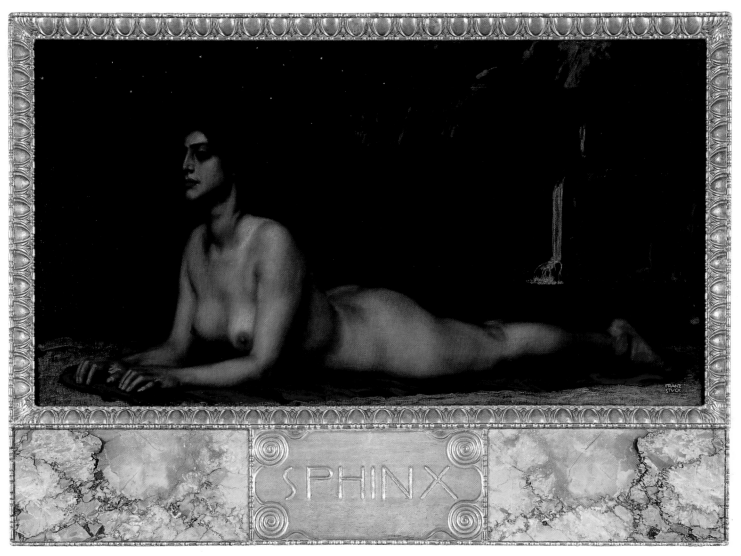

of life. *Fighting for the Woman* (1905; ill. p.44) shows two naked men, crouching and ferocious, skirting around one another, about to fight for the object of their desire. Next to these primitive men stands a woman with head held high. She observes the struggle with the same unmoved and superior facial expression as the sphinx.

In this painting Stuck included himself. The artist who shortly before had portrayed himself as the prince of art in frock-coat with a palette in his hand now posed for a photograph as a naked, fighting beast (ill. p.44). He put himself into the painting and thus brought it to life. Shortly before his death, in 1927, Stuck handled the same theme again in a purely decorative manner (ill. p.45). Here the fight has actually begun, and the bodies of the fighters are clasped to each other. They occupy one half of the painting; the woman with her body fearfully turned away occupies the other half. While in the first painting a dramatic *chiaroscuro* gives the bodies plasticity, in the second, light and dark are divided over the two halves of the picture, serving as a highlighting backdrop for the active bodies.

In 1904 and 1905 Stuck painted two pictures entitled *Wounded Amazon* (ill. p.47), similar iconographically and in their patterns of colour, to the image companion pieces of the dangerous, triumphant sphinx-woman. Two nude photographs and a drawing show Stuck's model Frau Feez in the pose of the Amazon kneeling on a pelt (ills. p.46). In the left-hand photograph she is holding an upright cardboard shield in her left hand; with her right she is

Sphinx, 1904
Oil on canvas, 83 x 157 cm
Darmstadt, Hessisches Landesmuseum
Stuck's *Sphinx* is a "strange version of a much depicted subject in which the fabled creature appears simply as a naked woman lying watching on her stomach supported by her elbows. The cat's body is not there at all, and still the creature is 'completely a cat' in expression and attitude, false and beautiful, flattering and dangerous. The name of this sphinx is – Woman!"
Fritz von Ostini, 1904

43

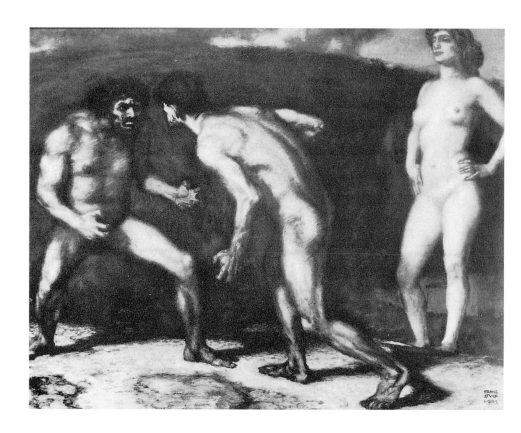

Fighting for the Woman, 1905
Kampf ums Weib
Oil on wood, 90 x 117 cm
St Petersburg, Hermitage

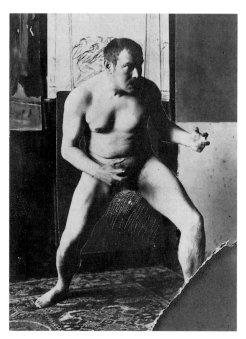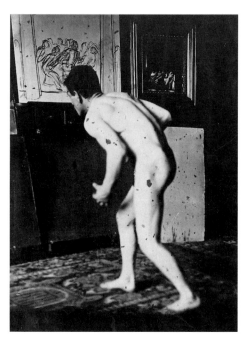

Photographic studies for *Fighting for the Woman,* c. 1905
Photographs
Estate of the artist

clutching her breast. The profile portrayal gives the clear outline used in the drawing. The second photograph shows pencil markings the meaning of which is clear, if we turn to the painting. All the studies feed into the painting itself. The soft, light-coloured body in combination with the red circular shield forms a sculptural unity decoratively contained by the almost square format of the picture.

Schmoll/Eisenwerth assumed that these remarkable photographs, quite different from customary photographs of models of this time, were taken in Stuck's studio without the help of a professional photographer. He remarked that "the photographic studies seemed to be 'staged' after the clarification of all compositional details", and that the artist then extracted a stylized form from the photographs. Stuck first made small sketches for the composition,

which "showed the disposition masses on the surface, which did not greatly change later".

This procedure differed substantially from that of other painters who had been using photographs since the mid-century as one means of increasing their productive capacity, like the portrait-painter Lenbach. Until 1968, when 110 photographic enlargements were found in Stuck's estate, the use Stuck might have made of photographs was not known. "Most painters who used photography concealed it and erased all traces of it." According to Schmoll/Eisenwerth, during this period the painter "silently included photography in the arsenal of his craft along with his brushes and pencils". The photographic studies here reproduced clearly show that Stuck did not consider photography an aesthetically inferior technical aid, but incorporated it into the creative process. While

Fighting for the Woman, 1927
Kampf ums Weib
Oil on wood, 71 x 73 cm
Estate of the artist
To a question about his major paintings Stuck gave this reply in 1892: "In choosing my themes, I set out to treat only the purely human, the eternally valid, such as the relationship of man and woman. 'He' and 'she' are present in most of my paintings. I try to glorify the man's strength and the woman's supple softness."

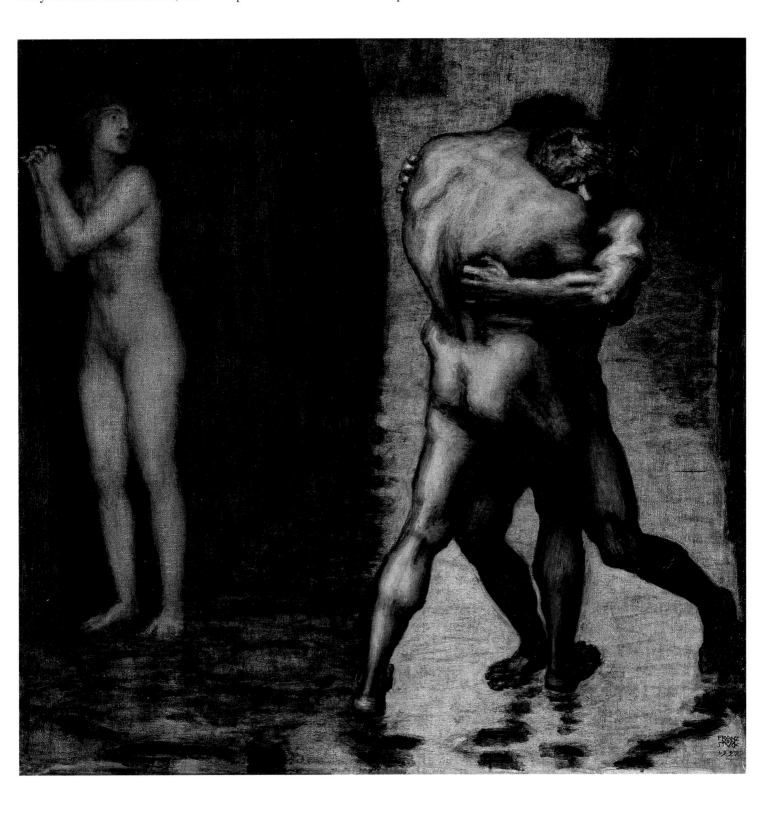

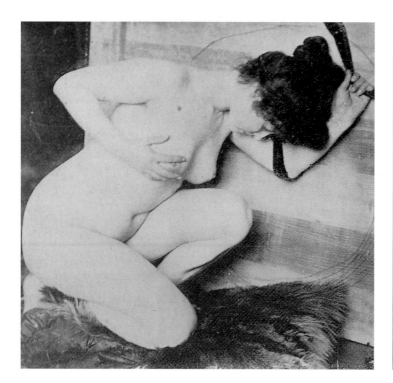

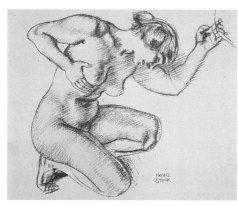

Study for **Wounded Amazon**, c. 1904
Red chalk and charcoal on paper, 40.2 x 44 cm
Estate of the artist

TOP:
Photographic studies of Frau Feez as the
Wounded Amazon, c. 1904
Photographs
Estate of the artist

his drawings served among other things to work out plastic effects, photographic work played a major part in finding the desired figural stylization and sometimes in the transference of the figures to the two-dimensional surface of the painting. It did not serve to guarantee the greatest possible lifelike similarity in portraits. It may be presumed that the creative work with photographic studies – which underwent great stylistic changes, from the posed, costumed study to the one-off autobiographical study – helped Stuck find his natural style as a painter.

In 1901, Bierbaum thus characterized Stuck's path from his early work to his master phase: "Masters become simpler and simpler, and so Stuck arrived at his great simple line, his broad simple colour. 'Great power', 'strong light', 'few halftones', 'simple lines and simple tonal relationships' – these requirements formulated by William Holman Hunt are met by Stuck. But these can only work when the composition is of corresponding power, grandeur and simplicity, and so placed in the space created by the frame that the whole thing really becomes a whole, becomes a picture. We no longer set up rules of composition and no longer believe in the secure basis of the pyramid form or such things: it is possible that a future aesthetic will derive rules from the great works of our time that are the basis of our idea of a beautiful line or balance of colour – but for now we can only say that it is a matter of aesthetic feeling. It is certain, however, that upon this feeling depends decorative impact as we see it today, and it is this feeling that makes the modern painter, whether he be a post-Impressionist who juxtaposes small spots of unmixed paint or, like Stuck, an artist who applies paint in generous fullness."

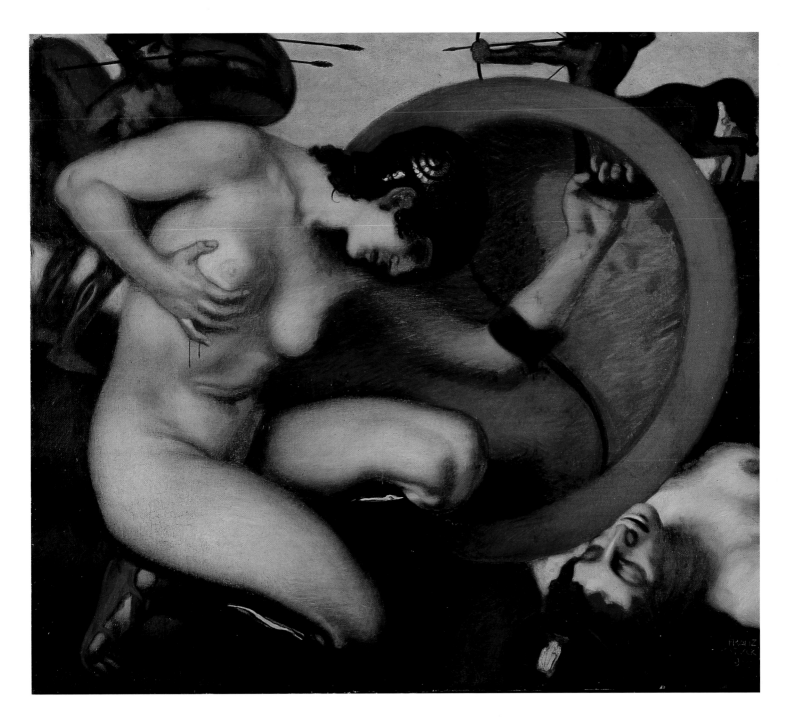

Wounded Amazon, 1904
Verwundete Amazone
Oil on canvas, 65 x 76 cm
Amsterdam, Van Gogh Museum
Frau Feez served as model for the drawing, photographic study, and
oil painting of this warrior from Greek mythology. The action in the
background is a mere backdrop for the bright naked body of the
wounded Amazon, plastically treated in front of the red shield.

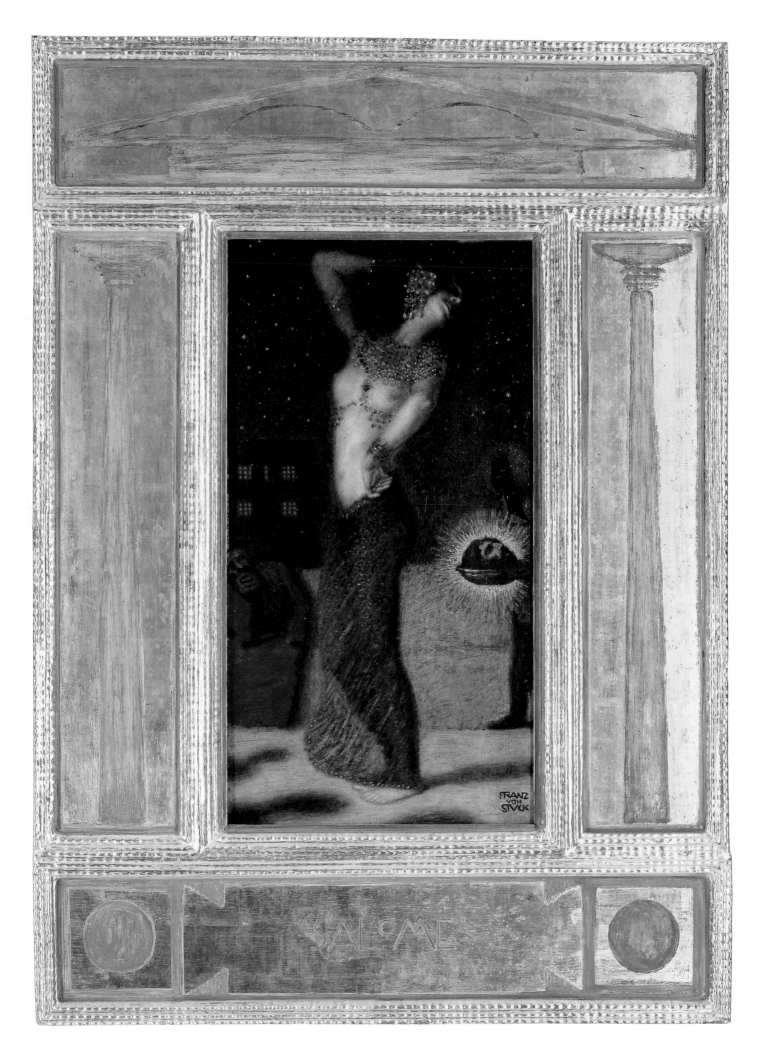

Franz von Stuck the Aristocrat

In December 1905 Franz Stuck was elevated to the aristocracy. Prince Regent Luitpold conferred on him the Knight's Cross of the Order of Merit of the Bavarian Crown. In January 1906 he was entered in the register of the peerage. He personally designed his coat of arms. Stuck chose a golden centaur leaping from left to right in black on a green ground. Richard Muther had already described Stuck as "a centaur leaping into our weary present" in 1893. In the meantime his pace had grown somewhat slower, but these arms fit Stuck precisely. At the height of his fame, he received a commission to paint a self-portrait (ill. p.49) for the gallery of artists' self-portraits in the Uffizi. Arnold Böcklin and William Holman Hunt had already been honoured in this way. Stuck's self-portrait is framed by two painted columns and two centaurs which hold his name in Roman carved style on a heraldic cross.

The former Secessionist had become an established artist, who according to younger artists had already peaked some years before. The new aristocrat Franz von Stuck was still interested in the same classical and timeless themes as before. He remained true to his principles and was concerned with creating "the fully human and the eternally valid." *Sin* and *The Amazon* and *The Sphinx* were followed in 1906 by two paintings of Salome (ills. pp.48 and 51). The figure of Salome was very popular among many kinds of artists at the end of the nineteenth century, from Moreau to Oscar Wilde and Lenbach. Stuck may have been inspired by Richard Strauss's opera *Salome*, which was first performed in 1905.

In Stuck's paintings, Salome is a slender young woman dancing with raised arms, head bent back, and naked from the waist up. Her chest (and in one painting her breasts), arms and head are bedecked with colourful jewels, while her lower body shows through a thin veil. On the right a servant is bowing, his face a grinning mask, offering his mistress the severed head of John the Baptist. The background, a dark blue starry sky, is reminiscent of the painted sky in Stuck's music room (ill. p.35 top right). Stuck treats the same subject in two different formats, sizes and correspondingly different compositions. The larger Salome painting (ill. p.51) forms a square with its frame; two painted Egyptian columns of papyrus bundles with Medusa heads on the capitals on a dark blue ground frame the figure at left and right. The three-quarters nude main figure is offset from the centre of the picture towards the left in order to make room for the black servant with John's head. The smaller upright rectangular painting shows Salome full-length (ill. p.48). The setting is suggested; the girl, who seems temporarily frozen amid ecstatic movement, is abandoning herself as if on-stage to the gaze of the audience on either side of the frame, as it were. Four broad gold panels surround this small painting, decorated with a column at left and right, a pediment above, and the title *SALOME* carved into the base panel of the frame. In both paintings the

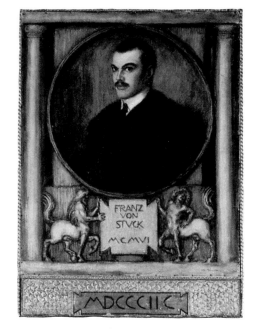

Self-Portrait, 1906
Selbstporträt
Oil on canvas, 102 x 108 cm
Munich, Museum Villa Stuck
After being elevated in 1905, Stuck – like Arnold Böcklin and William Holman Hunt – was asked by the director of the Uffizi to paint his portrait for the gallery's collection of artist's self-portraits.

Salome, 1906
Oil on wood, 45.7 x 24.7 cm
Private collection (Munich, Galerie Ritthaler)

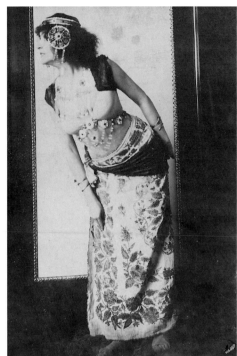
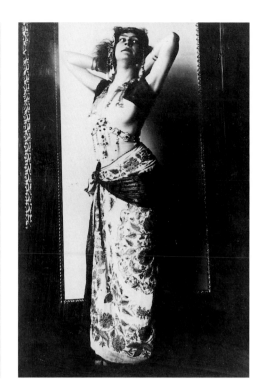

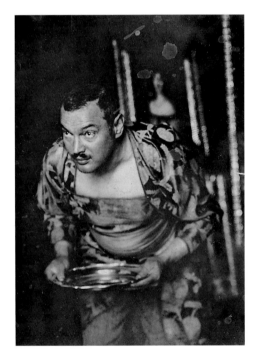

Photographic portrait studies for *Salome*,
c. 1906
Photographs
Estate of the artist

bejewelled female figure is reminiscent of another version of Salome. In the symbolist novel *Against Nature* (*A Rebours*; 1892), Joris-Karl Huysmans describes Gustave Moreau's *Salome* in words that might apply to Stuck's as well: "Her bosom heaved, and in touching the swirling necklace her breasts pointed upwards. On her young skin diamonds sparkled. Her bracelets, her belt, her rings threw off radiant sparks..."

Stuck posed for this painting too, this time in the role of the servant (ill. p.50 bottom). Stuck thus became a voyeur in his own painting; like Huysmans, he absorbed "the intoxicating magic of the illuminated figure". Like Dante Gabriel Rossetti, Stuck glorified "not this or that woman, but all women; he chose the feminine form as the vessel of his thoughts and desires, and he created his own type of beauty..." From Gauguin and Bernard to Munch, the *fin-de-siècle* painters "all contribute their individual conceptions of Woman, their emphases varying from destruction to creation and the eternal, from mother to whore". Hans Hofstätter once suggested that Salome, as the "archetype of the *femme fatale*" and "the social symbol of the turn of the century", was the "alter ego of the artist who realized that he was prostituting himself and betraying his most sacred feelings and secrets". Stuck's self-portraits, *Sin*, the *Sphinx* paintings and *Salome*, as well as photographic studies, all support this thesis.

If Stuck identified with his female figures in the manner described by Hofstätter, then he did so to an even greater degree with the figure of Pan. The small painting *Pan* (1908, ill. p.53) is integrated into its frame like a classical decorative wall painting. The broad, flat gold frame is painted with a pediment with a snake at each corner, two columns at each side, and a centaur at each corner of the socle. The upright figure of Pan stands at the centre of the painting in front of a bush, his syrinx (pipes) in his right hand. Glimpsed to left and right of him, between close-set trees, is a view of landscape and stormy sky. The columns on the frame continue the vertical symmetry of the picture, the *chiaroscuro* of which is likewise matched in the symmetrically placed gilt and dark painted areas of the frame.

This painting may well have been based on a dance-play by Otto Julius

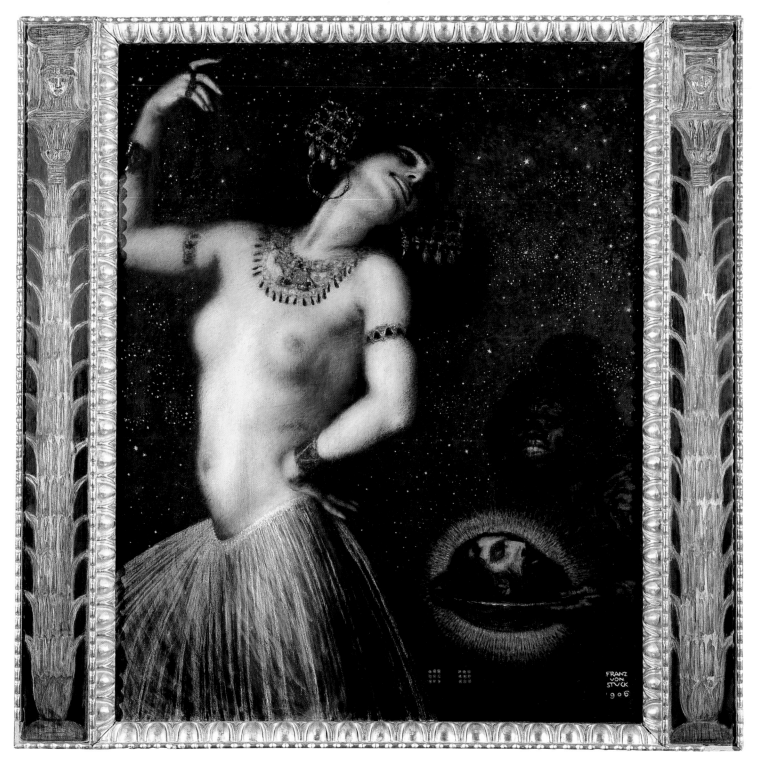

Salome, 1906
Oil on canvas, 115.5 x 62.5 cm
Munich, Städtische Galerie im Lenbachhaus
Artistic interpretations of Salome as the *femme fatale* reached their
high point at the turn of the century. Stuck had already treated implicit
crimes of passion in his personification of sin and the Sphinx. Here
man becomes the passion-object of the woman, and he is defeated
because he is no match for her provocative eroticism.

Bierbaum, *Pan in the Bush* (*Pan im Busch*), published in 1900 by Insel. The setting is "a German wooded meadow with beech trees around". One after the other the great Pan, Aphrodite, shepherds, water-sprites, priests and priestesses, fauns and satyrs, and even a school class, appear. Bierbaum sketches a liberated world, a world where youth can come together, a world healed by the joy of life of antiquity and freed from the moral constraints of the Wilhelminian society by the heathen Pan – and not by Freud!

Around the turn of the century, the figure of the unpredictable Greek shepherd-god inspired artists of all heritages as a symbol of new beginnings and the sexual liberation of both men and women. Pan, the shepherd-god and great lone wolf, the composite being with goat's legs and horned head, was experiencing a rebirth. His name was used as the title of the élite art journal onto whose board Stuck was elected in 1897 and whose emblem he had drawn when the journal first appeared in 1895 (ill. p.52). Pan symbolizes burgeoning and springtime, brings youth together, bewitches, bewilders, but also spreads fear, "panic". The figure of the syrinx-playing dual being embodies another dimension in Stuck's work beside the *femme fatale* who is incapable of love and brings disaster and death. Pan afforded the artist a counter-model to the sober present, a largely timeless Arcadia.

The large *Family Portrait* (1909; ill. p.54) clearly belongs to a different world. It is both a continuation of and a new direction from the double portrait *Franz and Mary Stuck in the Studio* (1902; ill. p.37). The poses of Stuck and his wife can be traced to the earlier work, but now they are seen on either side of their daughter Mary, who takes up most of the picture area, dressed in a Baroque crinoline. Stuck is wearing a fashionable grey frock-coat, palette in hand. Opposite him stands his sumptuously dressed wife, whose impressive beauty radiates like an exquisitely set jewel. Mary is wearing the Velázquez dress she wore at the last Secession exhibition. The dress, the hairstyle, and the stiff corsetted bearing are taken from Velázquez's portrait of the *Infanta Maria Teresa* (c. 1652; ill. p.55 centre). After the first great exhibition of Velázquez in London in 1862, the Spanish court painter had been rediscovered and revered by young artists. Three years before Stuck, this portrait of the Infanta inspired the Viennese Secessionist Gustav Klimt, who used it as a model for his portrait of Fritza Riedler (1906; ill. p.55 right). Klimt kept the stiff, majestic attitude of the royal model, but transformed the symmetrical composition of the original into an asymmetrical one. Furthermore, he modernized the *mise en scène*: upon closer inspection the crinoline becomes a Wiener Werkstätte armchair, the supposed hair ornamentation is revealed to be a brightly coloured glass window. The decoration of dress, armchair and background turn into an abstract pattern. Unlike Klimt, Stuck found not only aesthetic fascination in the *Infanta* portrait; he clearly placed himself as artist and prince of art in a line with the aristocratic Spanish painter who was knighted by his sovereign as well as being appointed Court Painter.

Bierbaum once posed the question, with Stuck's single and double portraits of before and around the turn of the century in mind, whether the German artist belonged in the tradition of the great portrait painters "from Velázquez to Whistler". In his opinion there was something superficial about Stuck's portraits that could be attributed to his "purely picturesque conception", and he himself therefore felt the answer was no. Bierbaum's criticism was still current when Stuck painted his family portrait with express reference to Velázquez; in an interview with Ostini in 1892 he had already observed that he was attracted to Velázquez most among the old masters.

In 1909 it seemed that he had finally succeeded in stepping into the tradition of his great model. In Felder's opinion, Stuck's composition, "a symphony in

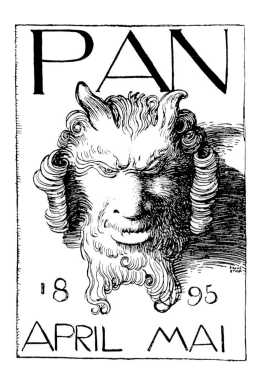

Cover of the journal *Pan*, 1895
The first issue of the ambitious art and literary magazine *Pan* was published in April/May 1895. Its first editor was Otto Julius Bierbaum, and its editorial board included Arnold Böcklin, Fernand Knopff and others. Stuck designed the cover.

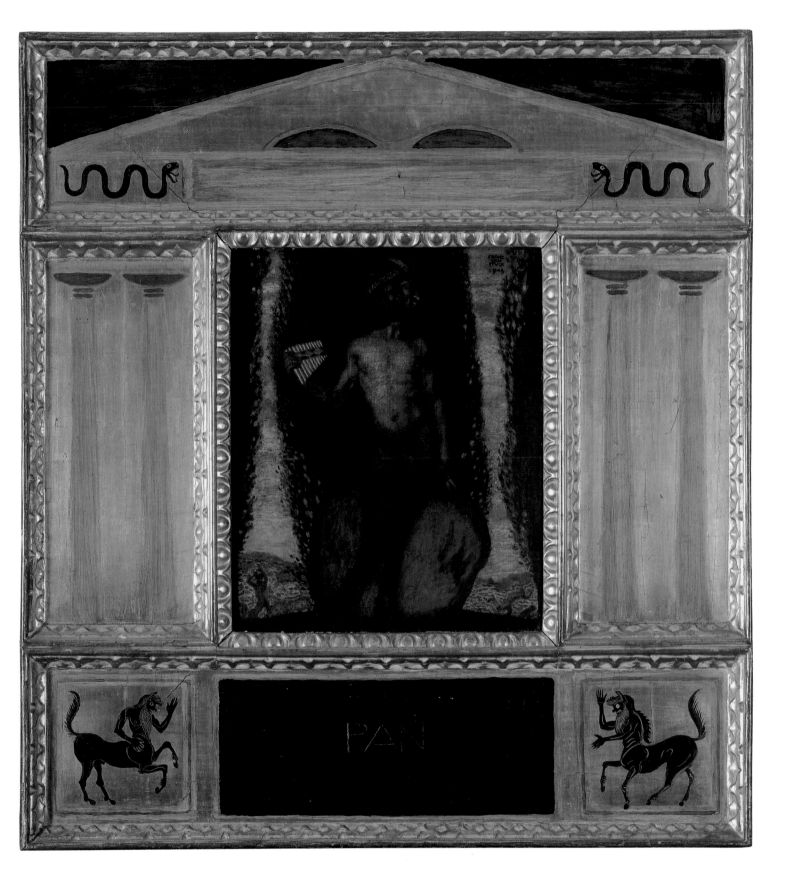

Pan, 1908
Oil on wood, 31.5 x 26.5 cm
Schweinfurt, Georg Schäfer Collection
"We are once again at the point where the key to understanding
Franz von Stuck begins: his understanding of Classical antiquity. Hardly
any other artist since the Renaissance has portrayed it so freely and so
variously as Stuck. Where others have experienced the cold of marble, he
experiences the laughter of life, where others have offered dead imitations,
he gives us colourful reality." Fritz von Ostini, 1909

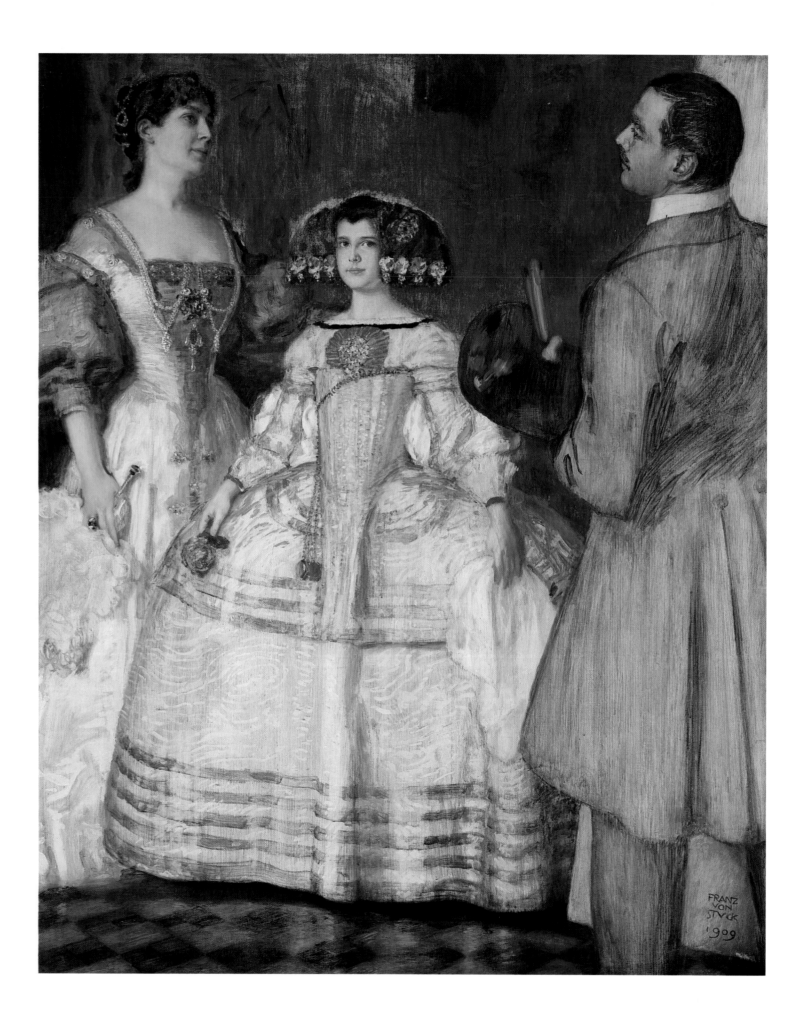

 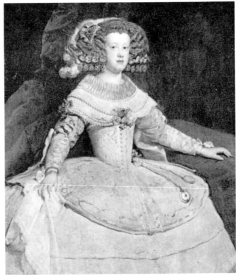

grey and red", is handled with a "virtuosity that works completely naturally, as in every great work of art". Today, however, it is precisely the composition that we are likely to find problematic. The figures touch but seem foreign to one another. Except for Mary, they have too little space in the composition, and they are all looking past one another.

Here again Stuck started from photographic studies, which may be a reason for the strange neutrality of the picture, in which these persons – despite their familiarity with one another – shun any visual contact. Mary, for example, posed for a photographic study (ill. p.55 left) as a fresh young girl in her Velázquez costume in the posture of the Infanta. In the painting she has become a solemn, secretive-looking child-woman whose facial features and expression are reminiscent of Stuck's earlier self-portraits. Perhaps this painting indicated that the aristocrat Franz von Stuck, honoured more than once by the heir to the Bavarian throne, now found himself, like his daughter Mary, in the restrictive corset of social position which, grand as it might be, no longer allowed him free development. Unlike the American Whistler, whom Bierbaum placed on a level with Velázquez, Stuck adapted completely to the society that had made possible his rise from miller's son to prince of art.

Stuck was more concerned with painting picturesque than psychological portraits, to use Bierbaum's words. This is demonstrated by the many portraits of Mary that he painted at the end of the first and during the second decades of the century. Based on photographic studies, they were assured of a certain degree of likeness, but they underwent the process of stylization that was habitual in Stuck's work from photographs to paintings. Photography as Stuck used it was not simply "a guarantor of the positivist-documentary", in the Expressionists' contemptuous formulation.

The regular and still unindividualized features of the young girl offered an excellent basis for aesthetic treatment. In the photograph, Mary is looking at us in her new motoring bonnet (ill. p.56), but in the painting this accessory becomes an ornament neatly fitting the head of the future *femme fatale* into the octagonal picture area, which is surrounded by a decorative frame. Formally this painting is reminiscent of Rossetti's paintings of women, and the motif of the face with a framing hat of a famous painting by William Holman Hunt. Other portraits show Mary as a *torero* or as a Greek girl (ill. p.57 right) with a classical profile and a corresponding hair style, or as a proud, somewhat chubby-cheeked Spanish girl (ill. p.57 left). These works are in differing formats, painted in different palettes and techniques, and with either canvas

Daughter Mary, c. 1910
Tochter Mary
Oil on wood, 31.1 x 31.1 cm
Estate of the artist

Mary Stuck, c. 1910
Photograph
Estate of the artist
Mary is here presented in her new motoring
bonnet. In her transformation to the subject of
a portrait, the child model becomes a Lolita,
the hat becoming an inner decorative frame.

or wood as the support. The numerous paintings of Mary, done as portraits,
masquerade studies or impersonal symbolic works, sold extremely well.

At this point, it is appropriate to return to the technical matter of working
from a model photograph to a painting. Schmoll/Eisenwerth, scrutinizing the
photographic studies that were discovered in 1968, noted that Stuck traced the
outlines of face or body with a sharp stylus onto the surface of the painting
itself. This procedure contains a stage of "abstraction from the model" since
in photography lines come into being only through the meeting of planes of
varying shades of grey. In the process of tracing the painter determines the
borders between these planes himself. The result is an incomplete structure
of lines that leaves much open. Only in painting over the tracing can and
must each individual line be clarified so that the form of the figure is fully
executed. This progress from photograph to work of art gives the artist a
comparatively free creative hand, since in tracing the photographic model
only "the likeness of the characteristic main lines of the head is guaranteed,
not its overall representation and expression". Ever since its invention, pho-
tography has played an important role in painting, not only for Stuck but for
other artists too. Yet this has never been fully examined, since right up until
the present day artists have concealed their use of photography in order not to
devalue their paintings as original works. According to Schmoll/Eisenwerth
painters from Delacroix, Courbet, Degas, Manet and Cézanne to Slevogt,
Munch and Picasso have used photographic material and studies in various
ways.

56

Mary as a Greek Girl, c. 1916
Mary als Griechin
Oil on wood, 31 x 29 cm
Estate of the artist

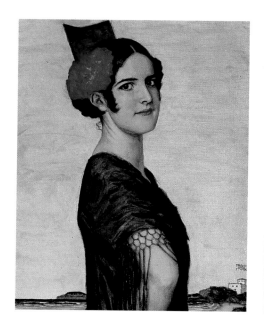
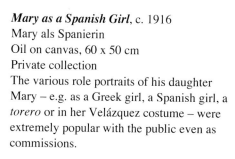

Mary as a Spanish Girl, c. 1916
Mary als Spanierin
Oil on canvas, 60 x 50 cm
Private collection
The various role portraits of his daughter
Mary – e.g. as a Greek girl, a Spanish girl, a
torero or in her Velázquez costume – were
extremely popular with the public even as
commissions.

In 1910 Stuck painted an overtly humorous work, *Dissonance* (ill. p.59).
Building on drawings and various photographic studies, he created a picture
that may only in small degree be called naturalistic; this study of a faun's
music lesson rather seems to us today a surrealist treatment. An infant faun is
practising on a Pan-pipe. His teacher, an adult faun with a muscular torso, is
sitting next to him on a hilltop. In theatrical pose he is covering his ears and
clenching his teeth while his student practises. Dismayed by the unintentionally
dissonant tones he is producing, the infant faun is looking at us and seems to be
shrugging his shoulders. Only the budding horns on his forehead mark him as a
future faun. Against a completely cloudless southern blue sky, the larger dark
body and the small light one stand out in their different proportions. The bodies
of both figures are three-dimensionally rendered and placed in sharp contrast of
light and colour values to each other and to the background. The frame with its
broad base bearing the title of the painting serves as an aesthetic counterweight
to the heavy mass of the dark body by taking up the light tones of the infant
faun.

The nude photographs of Stuck posing as an ageing faun must surely be
unique both in their content and their artistic value (ill. p.58 top). The prince
of art sits completely naked in his studio, laughing and covering his ears. These
photographs probably give a better insight into Stuck's character than many
official portraits. They relativize the emotive power and the myth of
the eternally youthful artist, the unapproachable aristocrat, the "Guardian
of Paradise", whose creative powers were supposedly weakened neither by

Photographic study for **Dissonance**,
Stuck as an old faun, c. 1910
Photograph
Estate of the artist

Study for **Dissonance**, c. 1910
Red chalk and gesso on paper,
61.6 x 47.6 cm
Estate of the artist

the ageing process nor by self-doubt. While the majority of his contemporaries tried to enhance their appearance and personality with the help of a professional photographer, Stuck uses the camera to drop the social mask. One may assume that Stuck and his wife Mary produced these photographs together. The painter owned a large plate camera which his wife knew how to use, and the Villa contained a photographic laboratory. The artist directed these photographs while his wife functioned as cameraman. Stuck either used himself as a model or he posed his model as her role in the painting required. Thus the stylization of attitude, perspective and expression intended for the painting are already present in the photograph. The photographs have the effect of individual studies composed with regard to the entire composition. The work of art was brought about by the combination of the perfectly preformulated individual elements of the picture. In this way Stuck's process was a synthetic one. His photographic studies and drawings also had important technical functions though, ensuring a precision and "correctness" of line and proportions, in the case of the photos, anatomical correctness and plasticity of the body in that of the drawings.

Stuck showed no fewer than twenty-seven paintings, five bronzes and two bronze reliefs at the International Art Exhibition in Venice in 1909. Before they were shipped to Venice, these works were shown in Munich for six days from 29 March to 4 April at the Galerie Heinemann. Among the paintings there were both older and completely new works, including *The Seesaw*, *Wounded Amazon*, *The Artist's Family*, *Mary as Torero*, *Pan*, *The Ride*, and probably the seminal *Spring Dance* (1909; ill. p.61).

Although still fixed in the iconography and revolutionary mood of the turn of the century's life-style and Art Nouveau aesthetics, *Spring Dance* is a masterpiece of decorative composition. Three couples with linked arms are performing a lively dance on a hilltop, naked or clad in colourful garments that blow in the wind. Above and beyond them is an almost stormy sky which fills practically two-thirds of the painting. The composition is stabilized by the vertical panels of the frame, dark painted and surrounded by wavy gilt mouldings, which contrast with the colour composition of the painting and complement its proportions. The 1912 painting *Spring* (ill. p.60) seems almost a Rackhamesque echo; spring is personified by a young girl with a floral wreath in her hair. In this painting we might well think not only of Botticelli but also of more recent youth and lifestyle movements such as "flower power" and hippiedom.

Spring and *Spring Dance* were painted on wood, not canvas. This was not exceptional; other paintings of 1912 and 1913, *Temptation* (ill. p.64 bottom), a portrait of the actress Tilla Durieux as Circe (ill. p.65 top), *Susanna and the Two Elders* (ill. p.63 left) and *Amazon and Centaur* (ill. p.67) were also painted in oil on wood. *Spring Dance* and the *Fighting Amazon* of 1897 (ill. p.28) were done in tempera and oil in order to achieve a smooth paint surface. In these works Stuck succeeded in "getting the paint to shine like jewels"; these paintings become an "intoxicating orgy of colour". A certain delight in experimentation was already evident in Stuck's early work. His first oil, *Wild Hunt* (ill. p.16), was painted on wood, and a short time later he used the opposite extreme of cardboard. Wood as the most expensive support, cardboard the least. It is clear that Stuck prepared the panels himself because they are of such varying sizes and proportions. For his rare large paintings he used canvas. Some paintings are on canvas laid down on wood, others are overpainted on photographic prints affixed to wood.

Discussions of and experimentation in technique have been extremely important for the course of painting since the middle of the nineteenth century.

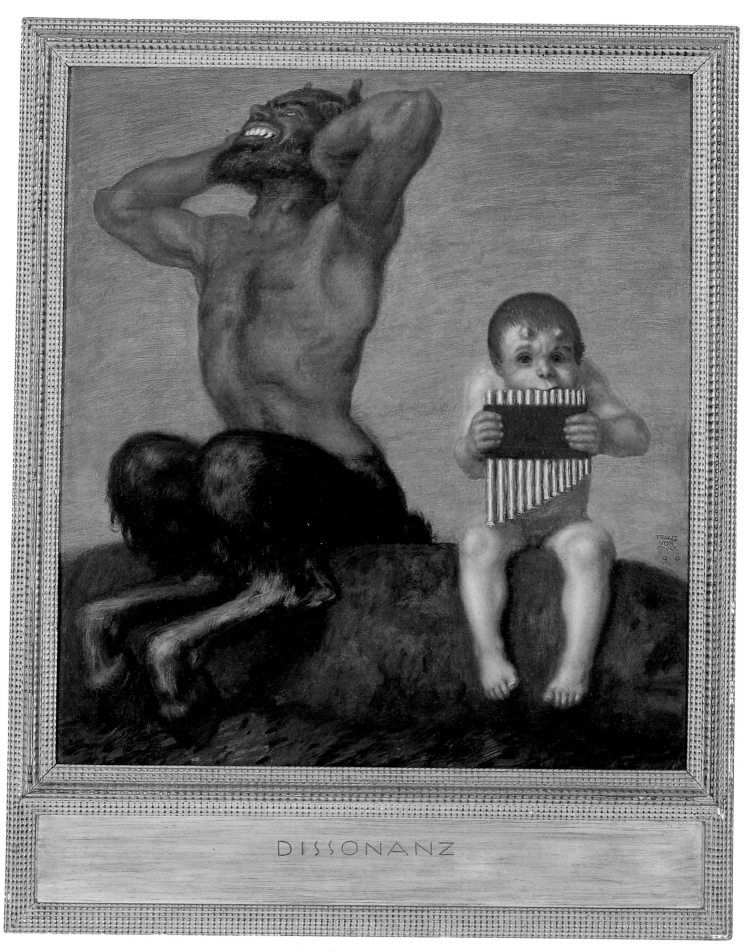

Dissonance, 1910
Dissonanz
Oil on wood, 76.7 x 70 cm
Munich, Museum Villa Stuck

Max Liebermann, for example, remarked in his book *Imagination in Painting* (*Die Phantasie in der Malerei*, 1904-06) that there is "no technique *per se*, but as many techniques as there are artists. Without individual technique, there is no art."

Industrialization brought a loss of traditional crafts in the course of the nineteenth century. Characteristically, the best of the Secessionists, among them of course Stuck, began their training at the College of Arts and Crafts. There the approach was very different from that of the Academy of Fine Arts, "considerations of method, material, colour and form taking clear precedence over questions of illustration or the representation of given subjects". The debate about craft and technical aspects and their influence on aesthetics is echoed in Stuck's work. In this regard, Stuck's concept of the frame plays a significant role. His frames are mostly meticulously carved and gilded, and are suited to the specific paintings they were prepared for; they are of quite a different order from the mass of characterless, ready-made frames constructed mostly from substitute materials.

An interest in different techniques and materials was not confined to painting during the Secessionist period. But in most cases the artist knew how and when to use them, and when not. The tendency to the three-dimensional, to the plastic or to the decorative and painterly was practised in the artistic disciplines that were ordained for them – architecture, sculpture, arts and crafts and fine art. Stuck's "leaning towards the plastic" hardly harbours a "danger for the painter", as Bierbaum had feared in 1901. Just as little as the frame intrudes on the painting, or, indeed, the painting governs the frame (often seen as a

Spring, 1912
Frühling
Oil on wood, 63 x 60.5 cm
Darmstadt, Hessisches Landesmuseum

Spring Dance, 1909
Frühlingsreigen
Oil and tempera on wood, 115 x 100 cm
Darmstadt, Hessisches Landesmuseum
This painting was one of Stuck's major new works at the International
Art Exhibition in Venice in 1909. In the facial features of the dancer
in the red robe the artist – rejuvenated – is recognizable.

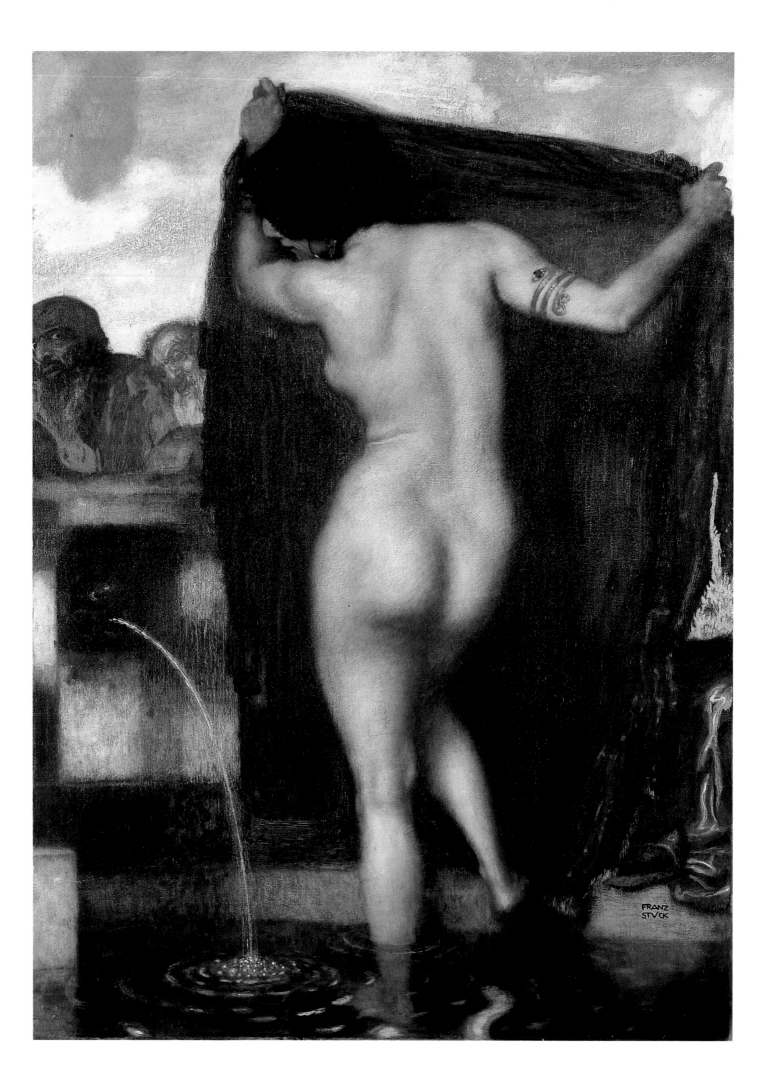

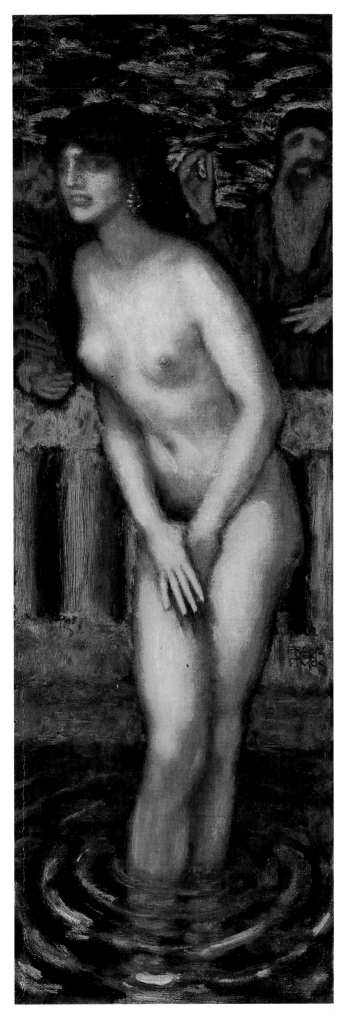

Gustav Klimt
Judith II (Salome), 1909
Oil on canvas, 178 x 46 cm
Venice, Galleria d'Arte Moderna

Susanna and the Two Elders, c. 1913
Susanna und die beiden Alten
Oil on wood, 56.6. x 17.8 cm
Estate of the artist
Both female figures have the same posture,
but Stuck's and Klimt's stylistic
interpretations of the theme differ greatly.
While Klimt integrates his figure into an
ornamental pattern, Stuck concentrates on a
sculptural treatment of the entire body.

ILLUSTRATION PAGE 62:
Susanna Bathing, 1904
Susanna im Bade
Oil on canvas, 134.5 x 98 cm
St Gallen, Kunstmuseum St. Gallen
Stuck depicts woman in the guise of a naked,
helpless Susanna exposed to the leering gaze
of the men. It is the viewer of the painting
who is the real voyeur, however, since the
two old men in the picture are denied the
desired view.

characteristic of Art Nouveau painting), does Stuck the craftsman compete with Stuck the painter.

With all their plasticity, works like *Susanna Bathing* (ill. p.62) or *Temptation* (ill. p.64) remain inside their frames. In both these works the curved, sculpted bodies stand out brightly against the background. In comparing *Susanna and the Two Elders* (ill. p.63 left) with Klimt's second version of *Judith* painted some four years earlier (ill. p.63 right), we can see formal similarities. Each work is in a narrow portrait format and contains a female figure bending towards the left. While Klimt's figure is woven into a colourful pattern and is two-dimensionally designed and essentially ornamental, Stuck's figure is naked and the body well modelled.

According to Ostini, woman "is at the centre of the artistic task, woman in the specific Stuck mould, healthy and of luscious sensual charm, woman as the stronger and more significant representative of the human race, woman as elemental power. Stuck is far from a feminist, and yet his entire œuvre takes its bearings from woman". If the Amazon embodies the type of the fighting woman who makes short shrift of men, there is always the seductress at her side, as in *Temptation* (ill. p.64) or *Tilla Durieux as Circe* (ill. p.65), both done around 1912/13. Extant sketches, drawings and photographic studies afford interesting comparisons.

Tilla Durieux, the famous actress born in Vienna in 1880, was one of the most popular of painters' and sculptors' models. In 1912 she played the title role of *Circe* by Calderón in Munich with great success. Stuck based his painting, as usual, on the photographic studies he had prepared. He took the attitude and

Study for *Temptation*, 1896
Pencil, pen, and black ink on paper, 12.1 x 12.6 cm
Estate of the artist

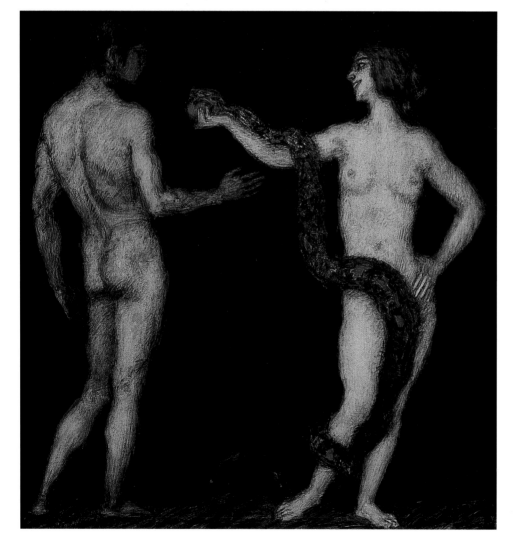

Temptation, c. 1912
Versuchung
Oil on wood, 48.5 x 46 cm
Private collection

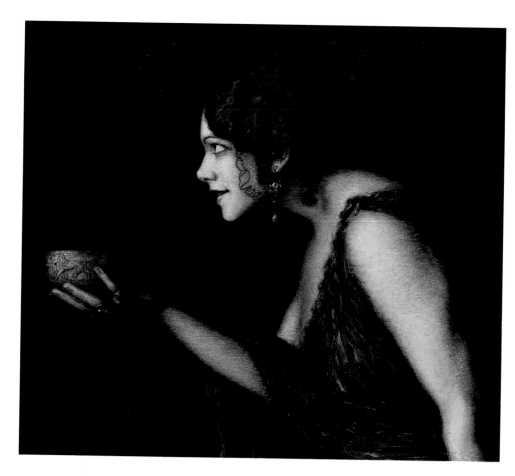

Tilla Durieux as Circe, c. 1913
Tilla Durieux als Circe
Oil on wood, 60 x 68 cm
Berlin, Staatliche Museen zu Berlin –
Preußischer Kulturbesitz, Nationalgalerie
Stuck portrays the famous Viennese actress
Tilla Durieux in the role of Circe. In Homer's
Odyssey Circe, a sorceress from Greek
mythology, lures Odysseus and his
companions onto her island. Odysseus
succumbs to her seductive charms. Circe
belongs to Stuck's cast of female figures who
bring about men's downfall through their
erotic power.

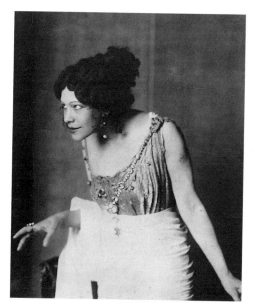

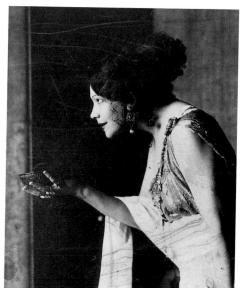

Photographic studies for ***Tilla Durieux as
Circe***, c. 1913
Photographs
Estate of the artist

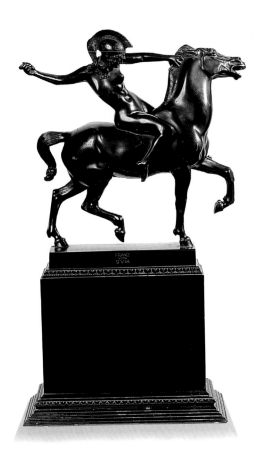

Spear-throwing Amazon, 1897/98
Speer schleudernde Amazone
Bronze, patinated brown, 65 cm high
Estate of the artist

expression from one, the well-balanced proportions from another. Circe is seen in the attitude of Eve in *Temptation*, but in profile. Eve's apple is transformed into Circe's bowl, the snake becomes a scarf loosely hung over an arm.

In 1892 Stuck had made his first sculptural work, *Athlete*, the shot-putter. There followed a series of small cast sculptures in large editions which were very successful; among them were *Dancer* (1897) and *Spear-throwing Amazon* (1897/98; ill. p.66). In 1909 five bronzes and two bronze reliefs were shown in Venice, as we have seen, among them *Athlete*, *Dancer*, and a bronze relief *Dancers* (1895). Stuck was "no one-sided specialist for whom bodies meant nothing more than colourful planes or geometric figures or the arbitrary play of impressionistic reflections of light; they have three dimensions, not one less or one more. Stuck knows their structure and as a sculptor knows how to render the tensed figure of the battle-ready Amazon or the powerful muscular effort of the shot-putter in a Promethean manner."

On only one occasion – in 1913 – did Stuck have the opportunity to execute one of his small sculptures again in monumental size. In 1912 he received a commission from the Cologne Kunstverein to recast the 65-centimetre high *Spear-throwing Amazon* life-size. For the new sculpture, for which Frau Feez was again the model, Stuck once more began by making arm and leg studies. Unlike the small sculpture, which like the Amazon portraits has a single pro-file view, the monumental sculpture may be viewed all round, involving an interesting foreshortening in frontal and rear views. It is possible that whilst Stuck was working on the large Amazon sculpture he thought about enlarging it into a monumental group. The painting *Amazon and Centaur* (1912; ill. p.67) may be seen in this context in that the figures are set on a high pedestal within the picture. The composition is symmetrical, the muscular bodies being set against a monochrome background plane. Eva Heilmann, a descendant of the artist, observes that it was painted as a design for a fountain, since "both fig-ures take up the theme of the Wittelsbach fountain. The close relationship of the figures to one another, spear and stone at the same level, movement and countermovement, these are features appropriate to plastic execution as a sketch clearly confirms." In expectation of further commissions for large pieces, Stuck had a sculpture studio built onto the Villa.

In 1913 Stuck celebrated his fiftieth birthday in the Villa. On this occasion he was named a Privy Councillor (*Geheimrat*) and an honorary member of the University of Munich. Stuck commemorated the event in two paintings, *Torch Procession* (ill. p.68 top) and *The Dinner* (ill. p.69). On the evening of 14 March a celebratory dinner was held in the studio; everyone who was anyone was invited. At the centre of this evening gathering are the artist and his wife, whose individual features are the only recognizable ones. Her figure is a ref-erence, reduced in size, to the double portrait *Franz and Mary Stuck in the Studio* (1902; ill. p.37). On 23 February 1913, Munich artists, art lovers and students gathered in front of Stuck's villa to honour him with a torchlight procession. Stuck went out onto the balcony in front of the brightly lighted windows. His silhouette can be seen in the painting, constituting the middle point of the façade.

Franz von Stuck was now at the pinnacle of his social career. Art in Munich, for those outside Germany, *was* Stuck; the work of this "most popular Munich artist is, to put it in the most modest terms, symptomatic of the rise or fall of the centrepoint of German painting". Stuck received ovations from artists and the public in 1909 in Venice, and he was honoured with the Italian orders of Mauritius and St Lazarus. In Germany, however, progressive art critics under the influence of French Impressionism had been casting doubts on his artistic skills and command for some years. Simultaneously Munich was losing its

reputation as a top-ranking art centre. Stuck, who was normally unvocal, pro-
tested against this in an article in *Nord und Süd* (*North and South*) in 1908.
He pointed to his own talented students – among others Eugen Spiro, Albert
Weisgerber and Willi Geiger – and maintained that "almost all academies and
arts and crafts schools in Germany get their teachers in Munich". Interestingly,
Stuck did not mention his former students Paul Klee or Wassily Kandinsky, in
1911 a founder of the group Der Blaue Reiter. Nor did he mention that the best
students of the younger generation included not only those called to the aca-
demies of other cities, but also those who left Munich of their own accord.

In 1906, in the manifesto of the artists' group Die Brücke, Ernst Ludwig
Kirchner, "in the belief in development, in a new generation of creators and
cognoscenti", had demanded that "the well-established senior powers should
grant young artists complete freedom". In 1911 Wassily Kandinsky, Alfred
Kubin and Gabriele Münter opened the first Blauer Reiter exhibition in Munich
with works by August Macke, Franz Marc, Robert Delaunay, Henri Rousseau
and Arnold Schönberg. A year later they showed the Fauves in a second exhi-
bition including works by Georges Braque, Maurice de Vlaminck, André
Derain, Michail Larionov and Pablo Picasso. The young artists of Munich were
represented at the Sonderbund exhibition in Cologne and in 1913 at the First
German Autumn Salon in Berlin. These crucial events in the course of art in
Germany passed Stuck by without trace. Nevertheless, with undiminished
energy, the well-established senior Stuck now created what were indubitably
some of his best works.

Amazon and Centaur, 1912
Amazone und Kentaur
Oil on wood, 42.5 x 59.5 cm
Estate of the artist
The Amazon is here juxtaposed with a
centaur. The symmetrical composition and the
integration of a painted pedestal into the
picture suggests its planned transformation
into a sculpture, possibly as a group of figures
for a fountain.

Torch Procession, 1913
Fackelzug
Oil on canvas, 50 x 53.5 cm
Estate of the artist

Menu for the dinner
celebrating Stuck's fiftieth
birthday, 1913
Estate of the artist

14 March 1913 Villa Stuck

Queen's Soup

Lobster Timbale

Roast Ham

Snipe Chaudfroid

Goslings

Salad, Compote

Fresh Asparagus

Ginger Sorbet

Cheese Tartlets

Fruit

14. MÄRZ
1913

VILLA
STUCK

KÖNIGINSUPPE

TIMBAL VON HUMMER

GEBACKENER SCHINKEN

CHAUDFROID VON SCHNEPFEN

JUNGE GÄNSE
SALAT, COMPOT

FRISCHE SPARGEL

INGWERGEFRORENES

KÄSETÖRTCHEN

OBST.

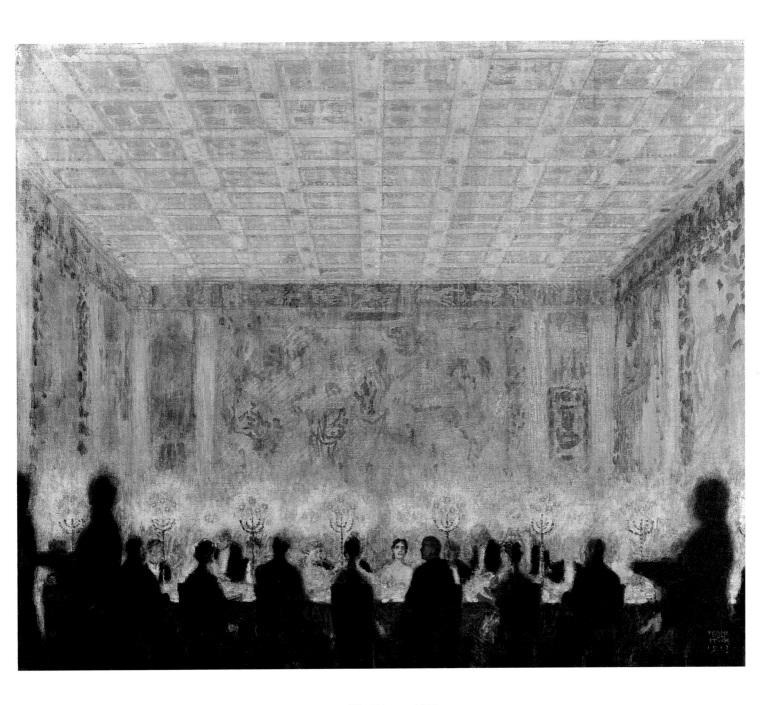

The Dinner, 1913
Das Diner
Oil on wood on canvas, 57.5 x 68.5 cm
Munich, Bayerische Staatsgemäldesammlungen, Neue Pinakothek
On 23 February 1913, Franz von Stuck celebrated his
fiftieth birthday. Munich artists, art lovers and students
gathered in front of his Villa to honour the master with a
torchlight procession. Some weeks later Stuck and his
wife gave a celebratory dinner in the studio for friends
as well as political and cultural luminaries of Munich.

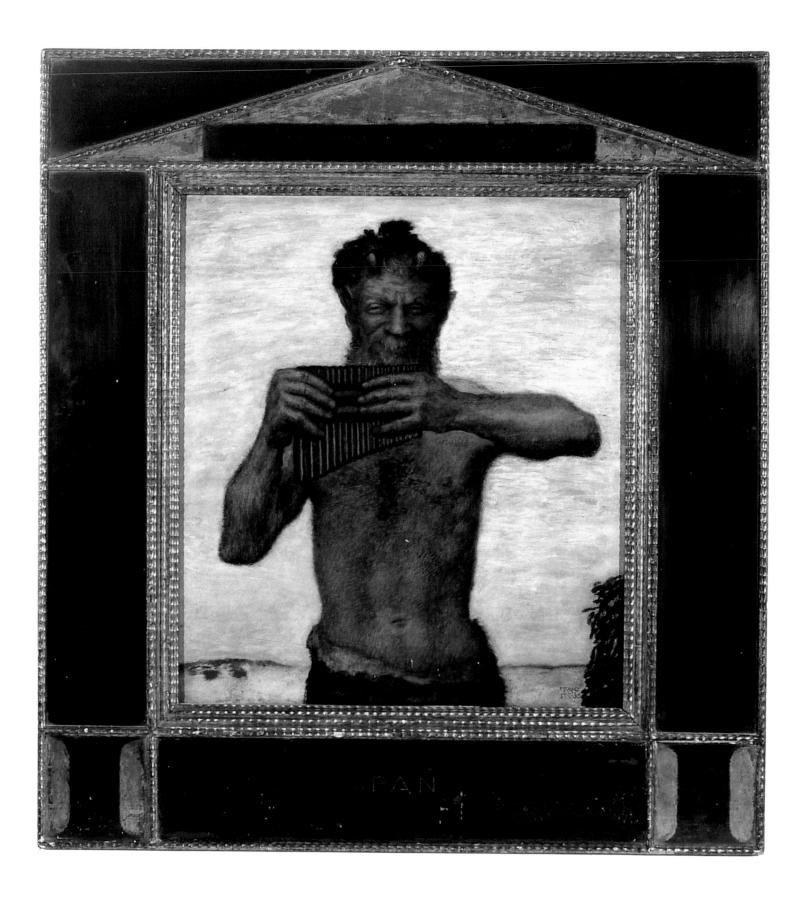

Under the Sign of Pan

When Stuck had a new studio built in 1914 by the firm of Heilmann and Littmann, just before the First World War, he hung a relief depicting a syrinx-playing Pan at the bottom of the staircase to his old studio, preferring the peaceful Pan to the fierce centaurs of his early and middle periods. In his last creative period Stuck led a far less busy working life than hitherto. During the first years of the war he still anticipated large sculptural commissions, but these hopes remained unfulfilled until his death in 1928. Times had changed. Stuck hardly exhibited any longer; his works were viewed as relics of an era that had died during the war and post-war upheaval. Despite this the years 1915, 1916 and 1917 brought Stuck further public honours. He became a Commander of the Swedish Royal Wasa Order, received the King Ludwig Cross for meritorious service in the war at home, and was made a member of the Viennese Academy of Arts. In the same year his daughter Mary married Consul Albert Heilmann, of the construction firm of Heilmann and Littmann.

Stuck seems to have had no further interest in self-portraiture during this time. His coat of arms with the fist-clenching classical centaur no longer seemed to fit him. From now on he worked under the sign of Pan, who stands above worldly interest. His last Pan works reveal something almost like the resignation of one betrayed by a nymph, of one who has striven for happiness and satisfaction, but has not achieved it. The figure of Pan also becomes a symbol of an arcadia that has come to an end. The outline of the Pan of 1920 (ill. p.70) contrasts darkly with the light background like a silhouette. The blunt, worn-down horns and grey hair are striking. His pipes held to his mouth, Pan gazes at the viewer with a sly smile. There is no other figure in the painting. It is tempting to connect this work with Bierbaum's poem "Pan's Flight", (Pans Flucht) written much earlier:

"In the green amid the flowers,
In the heat of noonday hours,
Far from gales that buffet Man,
Sits great Pan:
Carves a flute of lilac wood,
And, perceiving it is good,
Tender as the buds of May
Starts to play."
(translation by Michael Hulse)

In this poem Pan's sweet tones entice a young girl who follows him in anticipation of a beautiful young man. Her disappointment is great when she discovers an old goat. Her unmerciful laugh startles Pan so much that "he flees from there. Flees into deepest solitude/Safe from humans, far from humans".

Pan, c. 1913
Oil on canvas
Private collection

Pan, c. 1920
Oil on wood, 54.7 x 49.3 cm
Private collection
In his last creative phase, Pan acquires a special meaning for the ageing Stuck as a figure of identification. Pan is instinctive and cunning, subject to the drives of Eros, a husband of beautiful nymphs and shepherd boys, and closely bound to nature. Pan belonged to the intoxicated, half-animal retinue of Dionysus; in philosophical-mystical conception he was an omnipotent deity.

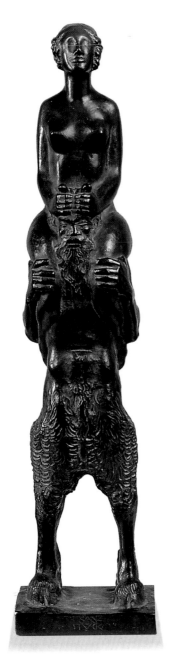

Faun and Sea-Nymph, c. 1918
Faun und Nixe
Bronze, patinated green, 53 cm high
Estate of the artist

ILLUSTRATION PAGE 73:
Faun and Sea-Nymph, 1918
Faun und Nixe
Oil on wood, 155.7 x 61.5 cm
Estate of the artist
Stuck once again expresses the turn-of-the-century exuberation for feeling in this painting. Otto Julius Bierbaum, who likewise evoked Arcadia in his poetry, conceived the relationship of the sexes in the following manner: "The happy pair are in Arcadia and know without Nietzsche that everything one does for love is beyond good and evil."

The girl's behaviour is comparable to contemporary criticism, which – in so far as it devoted any attention to Stuck's work at all – still could not resist his "extraordinary talent", his "sweet flute tones". Pan, once the symbol of youth and *fin-de-siècle* criticism of Western civilization, was now nothing more than a comic old fellow. The younger generation had as little understanding for Stuck's Arcadia, rooted in an earlier era, as he had for the new directions of art and current artistic debate. In his work there is no reflection of historical events; instead we find constant reference to the problem of ageing in his private world of fable. In his last creative period Stuck returned to earlier pictorial conceptions that suited this subject. Return to the past coincided with a new interest in sculpture noticeable from 1913 onwards.

A good example of the relationship between Stuck's sculpture and his painting is the painting *Faun and Sea-Nymph* (1918; ill. p.73) that goes back to a sketch of 1902 and also relates to a small sculpture (ill. p.72) of the same title and dating from the same year. The large, vertical painting shows a pair of lovers no longer in their first youth. A bright-skinned, plump nymph is sitting on the shoulders of a massive faun who is carrying her from the water. Her broad bottom and colourfully shimmering fishtail snuggle against the shoulders and head of the faun, and with both hands she holds his horns. Whilst the nymph's face shows no individual features, the faun's head resembles the Pan of 1920. His body with its goat's legs are wholly visible; the muscles are concealed by a layer of fat. Behind the strange couple a sea coast can be seen. The open space behind them emphasizes the plasticity of the figures. While the juxtaposition of the contrasted bodies gives a certain liveliness, their plasticity is achieved through strict, frontally presented symmetry.

Stuck had painted this subject, here handled in a plastic and painterly fashion, for the first time in 1902. The 1918 painting differs from the earlier, almost square work in its format and the strictness of its composition. It can be assumed that the later painting preceded work on the sculpture. It is, however, much more than a mere transitional work on the way to sculpture; despite the qualities it shares with the sculpture it is truly a painting. In both works the couple are compressed into a vertical rectangle, and their relative proportions are similar. The couple in the painting are arrested, in motion; in the sculpture all signs of movement and liveliness have gone. The undecorated frame of the painting is as plain as the flat, unadorned rectangular bronze base to the sculpture. According to Eva Heilmann, this sculpture was not intended as a finished piece; "the pair of figures arranged one on top of the other" was to have become the centrepiece of a fountain, probably intended to be cast life-size.

Several oil sketches dating from between 1917 and 1923 show Stuck beginning to experiment with colours and techniques he had not used before. The small watercolour sketch *Spring* (ill. p.74), shows a seated Pan playing the flute with a naked nereid lying before him. A composition featuring thick flowing outlines is flanked by dark rectangular planes to the left and right that correspond to sides of a frame.

The oil sketch *Danae* (1923; ill. p.74 bottom) shows a reclining nereid from the side. Here the decorative style of the watercolour sketch turns into a naturalistic, plastic one. *Monna Vanna* (1920; ill. p.75), in its sketchy, loose style, resembles *Danae*, but is less plastic. While both these sketches were done as preliminaries for paintings, *Monna Vanna* was also cast in bronze with a slightly different pose.

In comparison to the recent past, Stuck was extremely productive in 1920. A carefully produced photograph shows the artist in his studio with short-cropped white hair. He is standing in front of the painting *Sisyphus* and the sculpture of

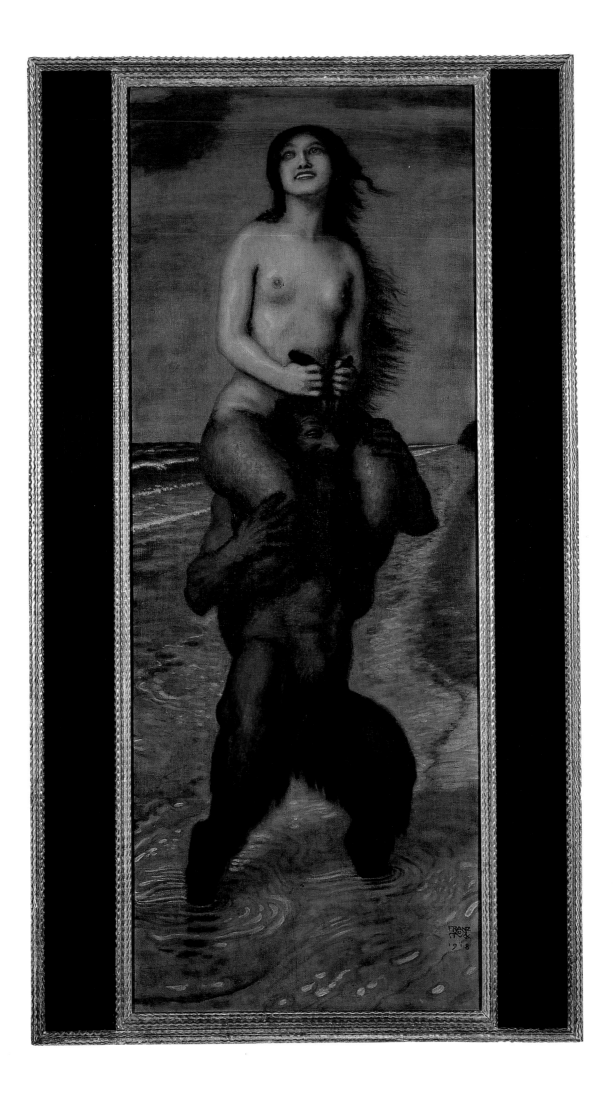

TOP:
Spring, 1917
Frühling
Watercolour over pencil, 12 x 15 cm
Kaiserslautern, Pfalzgalerie Kaiserslautern

BOTTOM:
Danae, c. 1923
Oil study, 29.5 x 34.4 cm
Estate of the artist

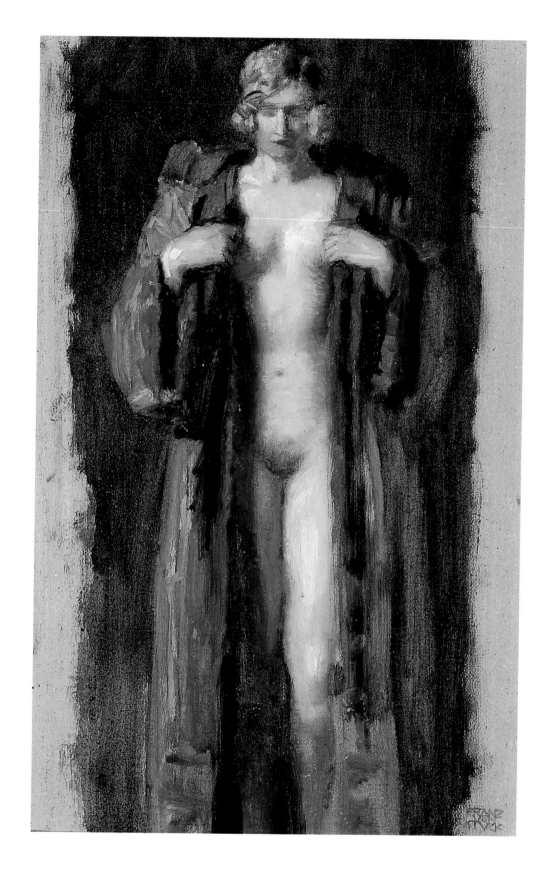

Monna Vanna, c. 1920
Oil on board, 55 x 35 cm
Estate of the artist

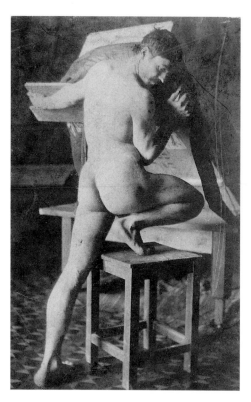

Photographic study for *Sisyphus*, c. 1920
Photograph
Estate of the artist

Stuck in his studio at work on
Sisyphus, c. 1920
Photograph
Estate of the artist

ILLUSTRATION PAGE 77:
Sisyphus, c. 1920
Oil on canvas, 103 x 89 cm
Private collection (Munich, Galerie Ritthaler)
The mythological figure of Sisyphus is one of
the best-known penitents of the underworld.
The gods' punishment for his hubris is the
task of pushing a heavy boulder up a
mountain down which it always rolls back
after reaching the summit.

a contemplative Helen, palette in hand (ill. p.76 right), turned towards us. His expressive facial features are particularly well caught in this three-quarter-length portrait.

The photograph makes several statements. The artist indicates his two main areas of activity, painting and small-scale sculptures, but he presents himself as a painter. Helen and Sisyphus, characters from classical mythology by which Stuck continued to be inspired as earlier in his career, are not without relevance to Stuck's own situation in life: Helen, the most beautiful of all the women in Greek mythology, turns away from Stuck, deep in thought, perhaps pining over the past. Sisyphus, beside her, is portrayed not as the canny victor over death, but rather as a penitent in the underworld paying for his sins by pushing a heavy stone to a summit with all his power – only to have it roll down again when it has reached the top. The subject of the painting is reminiscent of the first small sculpture by which Stuck became known, the shot-putter of 1891/92. Stylistically, *Sisyphus* (ill. p.77), painted in the threefold antique palette of black–white–red, corresponds to the *Wounded Amazon* (ill. p.47). Stuck's first *Sisyphus* was painted in 1899, its "plastic radiance" being enthusiastically noted by the French art historian André Germain. It was probably Stuck's increased attention to sculpture that led him to paint *Sisyphus* once again around the year 1920.

Stuck's works generally lack reference to the social, political and cultural upheaval brought about by the First World War. One exception is the sculpture *Surrounded by Enemies* (1914; ill. p.78 left), the title taking up the slogan coined by Kaiser Wilhelm II at the beginning of the war. Eva Heilmann observes that the "wielder of the sword always appeared with different titles on war bond posters". The same warrior appears in a painting of 1915, *Hercules and Hydra*, (ill. p.78 right) as a heroic blond man; in this transposition of the sculpture into painting, within a decorative frame, the subject is to a certain

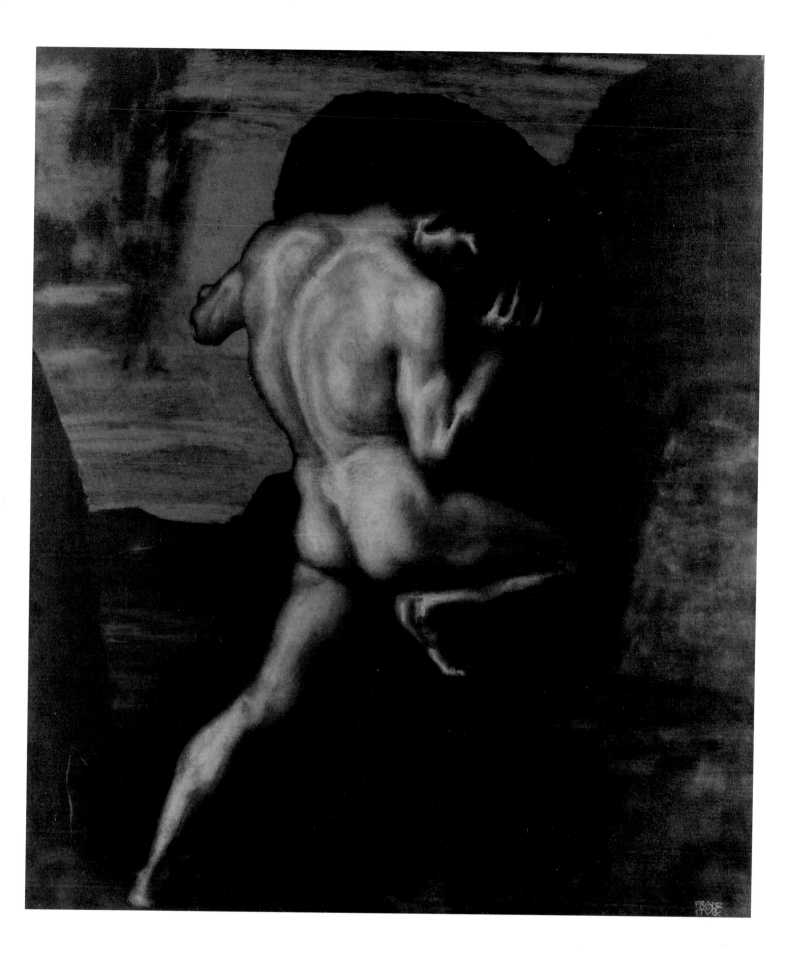

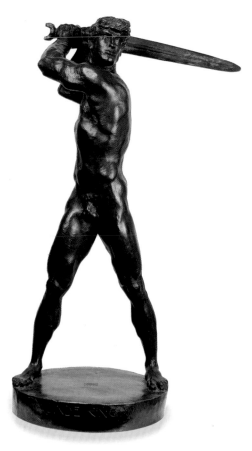

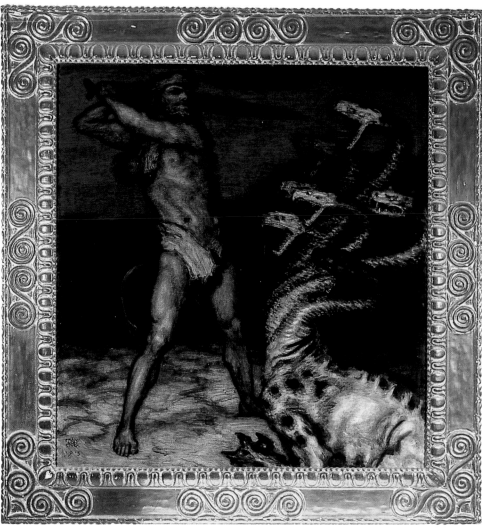

Surrounded by Enemies, 1914
Feinde ringsum
Bronze, patinated green, 71.5 cm high
Estate of the artist
The title of this sculpture takes up the slogan
current in Germany at the beginning of the
First World War. The warrior reappears one
year later in a painting as Hercules fighting
the many-headed Hydra.

Hercules and Hydra, 1915
Hercules und die Hydra
Oil on canvas, 110 x 104 cm
Private collection

The Affliction of the Nibelungs, c. 1920
Der Nibelungen Not
Oil on wood, 98 x 41.2 cm
Estate of the artist

Compositional study for *The Affliction of the Nibelungs*, c. 1920
Black chalk on paper, 53 x 38 cm
Estate of the artist

Compositional study for *The Affliction of the Nibelungs*, c. 1920
Pencil on paper, 43.7 x 29.7 cm
Estate of the artist

extent dematerialized, losing its contemporary meaning by being placed in a world of classical mythology.

Around 1920 Stuck painted another work that had an indirect reference to his day. *The Affliction of the Nibelungs* (ill. p.79 left) refers to Germany as the loser of the war and to post-war hardships. But this painting does not represent a critical statement or indictment as did those by Otto Dix or George Grosz, also involved in the war. The sketches for this painting show that Stuck was more interested in the futuristically angular figures of the warriors descending the staircase – which are not entirely integrated into the painting – than in the content.

Stuck's creativity now passed more markedly under the sign of Pan, whose timeless character transcended events of the day. To around the year 1920 belongs the oil *Pan* already discussed (ill. p.70), as does a painting entitled *Spring* portraying an ageing centaur walking at a calm pace through a spring-time landscape. Lonely and deep in thought, he is absorbed in playing his flute. Pan and his analogues, like his creator Stuck, have become older, and like human beings are subject to the laws of life and time. But here we have a cyclical view of time, one of nature constantly renewing itself. Stuck returns to the flat decorative style of around 1909, which peaked in his painting *Spring Dance* (ill. p.61).

Stuck also painted a counterpart to the image of the ageing Pan in 1920, *Abduction of the Nymph* (ill. p.81), one of the major works of his later period. This was a reworking of design from the volume *Allegories and Emblems* of 1888 into an oil. A centaur, with a cupid riding on his back, is lifting a naked nymph into the air and pressing his head gently against the white body of the happy nymph, who is laughing. The nymph and the impudent little cupid, an arrow held in his left hand, look out at us like conspirators who have in fact arranged this abduction.

The painting gains great force from the broadly layered progression from the dark tones at the bottom to the light ones at the top, where the figures melt into a background of blue sky and pale clouds. With all its baroque lust for life and the dynamism of its steeply rectangular composition, the painting still makes a static impression, perhaps as a result of Stuck's increased preoccupation with sculptural problems. Paintings like *Abduction of the Nymph* were seen by contemporary critics as an indication that in Stuck's works "antiquity is more Italian than Greek", leading to the conclusion that "this illogical mingling of the baroque and the antique, this nonsense of a baroque antiquity, is a *Bavarian* creation".

The Three Goddesses (1923; ill. p.82) is completely different from the previous three works; the goddesses are composed as individual figures with a view to their translation into sculptural form. The figure of Aphrodite, for example, was in fact transformed into three-dimensional form as a small sculpture (1925; ill. p.83 right). While the basic pose is preserved, the lifted arms in the painting are integrated into the sculptural mass of the body. Aphrodite, who in the painting wears a transparent veil which emphasizes her nudity, is trans-formed in the sculpture into a contemplative and chastely dressed Helen.

The front view of the sculpture appears in 1925 as a painting of the same title in upright rectangular format whose composition is completed by two vertical white framing panels (ill. p.83 left). The figure of Helen with her Greek profile, painted in light tones against a dark background, stands on a plinth within the painting on which the following lines from Homer's Iliad are painted in Latin script: "Do not blame the Trojans or the helmeted Achaeans/ Who waited so long in such misery for such a woman!/ The one we see indeed

ILLUSTRATION PAGE 81:
Abduction of the Nymph, c. 1920
Nymphenraub
Oil on canvas, 140.5 x 89.5 cm
Private collection
Stuck first drew this theme for *Allegories and Emblems* (p.13). In 1920 he returned to a subject containing pent-up energy expressed in a baroque-like dynamic.

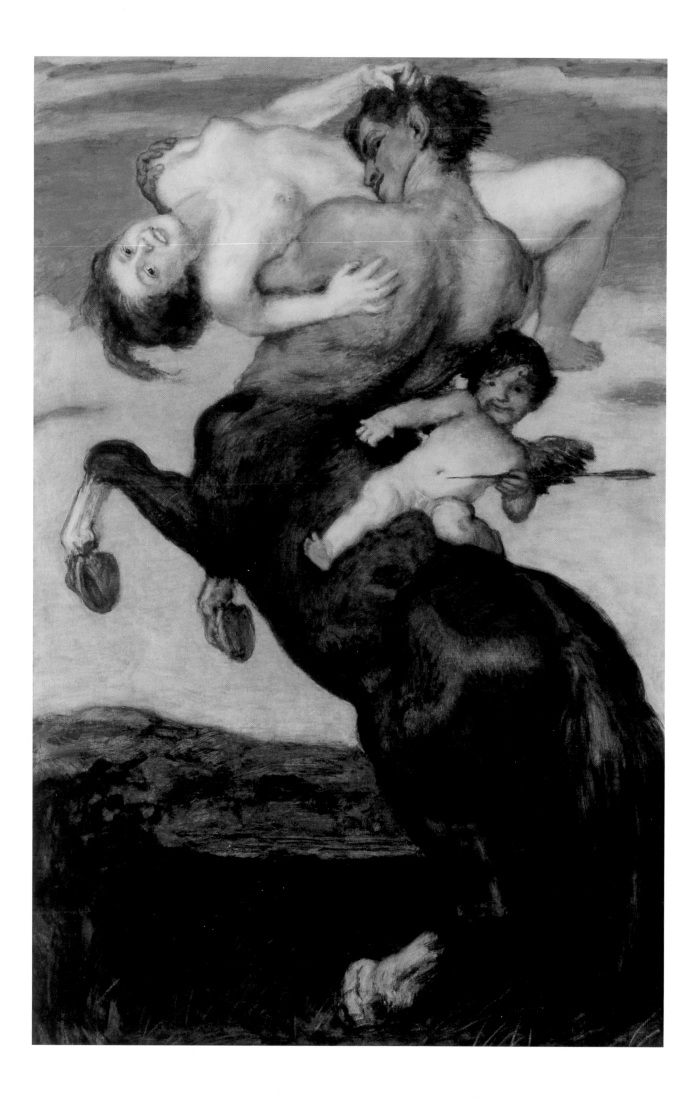

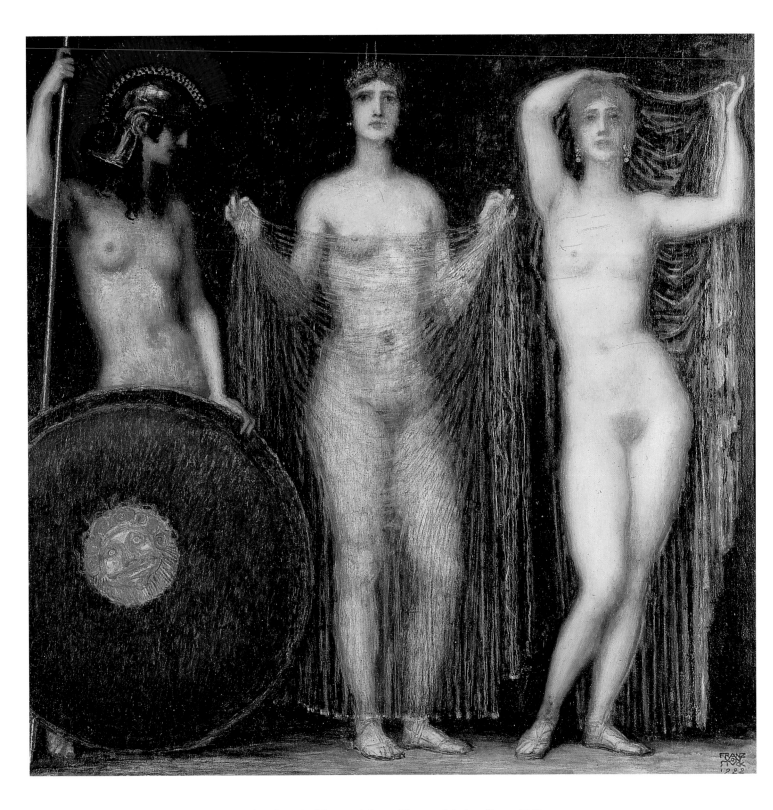

The Three Goddesses: Athena, Hera and Aphrodite, c. 1923
Die drei Göttinnen: Athena, Hera and Aphrodite
Oil on wood, 73.5 x 74 cm
Private collection

TADELT NICHT DIE TROER VND HELLVMSCHIENTEN ACHÆER
DIE VM EIN SOLCHES WEIB SO LANG AVSHARREN IM ELEND!
EINER VNSTERBLICHEN GÖTT IN FVERWAHR GLEICHT JENE VON ANSEHN!
HOMER · ILIAS

Helen, 1925
Helena
Bronze, 70 cm high
Munich, Museum Villa Stuck

Helen, c. 1925
Helena
Oil on wood, 90 x 34 cm
Estate of the artist
The defeat of Troy is a consequence of the
seductive art of Helen, described by Homer
as the most beautiful of all women.
Helen destroys not merely one man, but
an entire city.

resembles an immortal goddess!" This example of seemingly simultaneous and almost playful use of different media indicates that here once again Stuck was working and experimenting with a single compositional model.

These baroque and classical works stand in contrast, in content and form, to two somewhat earlier paintings, *Ostrich Hunt* (c. 1919; ill. p.85 bottom) and *Tobogganing Children* (c. 1922; ill. p.85 top), both of which are based on much earlier ideas. *Ostrich Hunt* depicts the innocent pleasures of two satyrs. A similar schematic approach is evident in the painting of each of these works; in *Tobogganing Children* Stuck is grappling with the problems raised by *plein-air* painting. These two paintings were praised by contemporary critics as Stuck's essays in an Impressionist manner; but the wheel of taste has come full circle, and today these paintings tend to be derided.

Shortly before his death in 1928, in the year of the global economic crisis, Franz von Stuck was awarded an honorary doctorate by the Technical University of Munich. In the same year Hugo Lederer, director of the Master Studio for Sculpture in Berlin, proposed Stuck as a candidate for the *Pour le Mérite* order, a special honour for Stuck as architect and sculptor. Stuck the painter, however, met with wide disapproval, as too did Böcklin. He stood for the Art Nouveau era in his critics' minds, and an Idealist conception of art that in their opinion had been buried by Impressionism and Expressionism.

After the turmoil of the First World War and its cultural, economic and political aftermath, the following generation found it impossible to identify with Stuck's world. The art movement identified in Germany with the figure of Pan had finally ceased to exist during the war. Stuck's qualities as a teacher of composition at the Munich Academy were never questioned, though, either at this time or after his death in 1928. He himself may have totally rejected the new art movements, but it was still possible for a future teacher at the Bauhaus, the German artist Josef Albers, to study with him as late as 1920.

Tobogganing Children, c. 1922
Rodelnde Kinder
Oil on canvas, 42.4 x 69.2 cm
Estate of the artist

Ostrich Hunt, c. 1919
Straußenjagd
Oil on wood, 59.5 x 59.5 cm
Regensburg, Staatsgalerie Regensburg,
Bayerische Staatsgemäldesammlungen
"Movement here is wonderfully made
visual... This style of painting, in which
Stuck, the master of decorative art, becomes
an Impressionist, has more to offer me than
many works of his dramatic and heroic
palette, more than the colourful extremes of
his fantastic paintings. Here is eternal
youthfulness." Heinz Langer, 1920

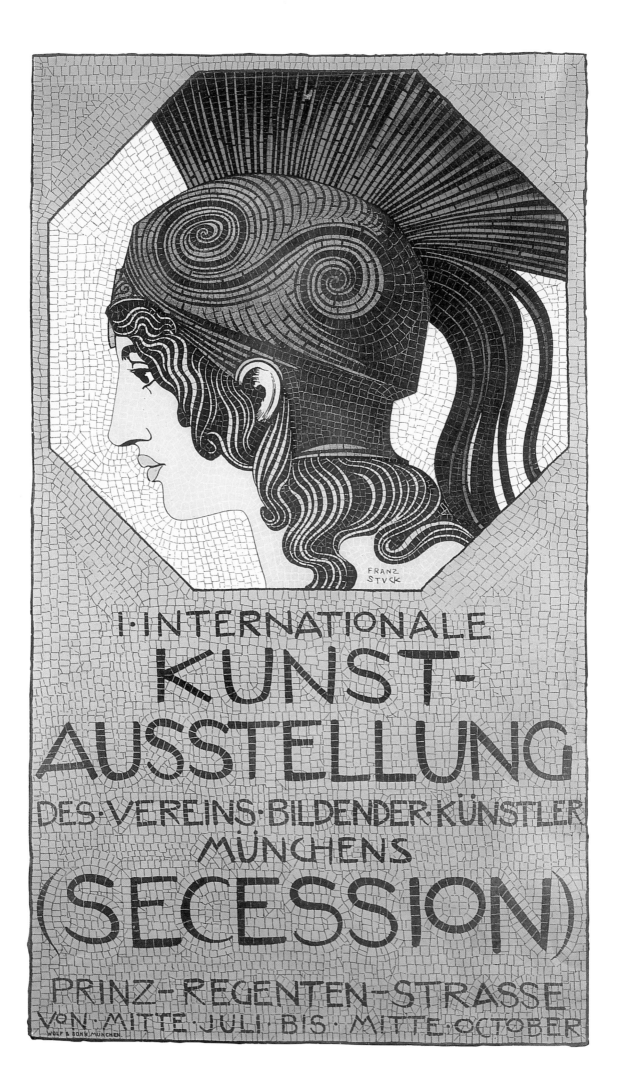

Prince and Teacher of Art

The bust of Pallas Athene had become the symbol of the Munich Secession since their first exhibition in 1893. Stuck had designed the impressive poster (ill. p.86) that was used up to the 1930s to advertise Secession work. The artist recognized early on the importance of promoting a consistent image. It is no accident that when critics now discuss the career of Stuck they do so in terms of stage management and direction. Bierbaum observed admiringly in 1901: "His art is everywhere and in everything, and his life is not his worst artwork." Stuck not only designed his living environment and both his studios, but played an active part in the way in which his work was exhibited – in Venice in 1909, for example, where "several special salons of elegant simplicity were created after the master's designs". The impact made by the first exhibition of the Secession in Munich was due above all to the aesthetic effect of the revolutionary hanging style, which focused on the individual work. Stuck's self-portraits both with and without his family were part and parcel of his stage managed career. The lone genius, the prince of art who painted in a frock-coat, he completely fitted the hero cult of the late nineteenth century.

Stuck's compositions, of openly erotic and sexual content, corresponded to the repressed fantasies of the prudish Wilhelminian age. On Stuck's death in 1928, Wilhelm Hausenstein declared that "in Germany and beyond, almost everyone has a very clear conception of Stuck. Everyone has seen either *Sin* or *Sensuality* – the paintings with a naked woman and a snake." André Germain saw Stuck as the personification of the *rêve allemand*, the "German dream". In his opinion Stuck's paintings were not only the mirror and soul of the artist but beyond that "a reflection of the contemporary German soul".

Contemporaries were able to identify with Stuck's life and work. Both were a part of the promotable *Gesamtkunstwerk* in the "Stuck style"; one is almost tempted to speak of a Stuck Enterprise with a corporate identity. Stuck represented the society that celebrated him. He interpreted their desires and incorporated them in paintings, employing accessible symbols conveyed in a pictorial language that was thoroughly modern at the time. And here lay a further factor in Stuck's success: as a young artist he represented the cause of the modern in Munich. There it did not mean, as it did in France, exclusion from all official exhibitions. As a progressive artist, Stuck lived like a successful stock exchange dealer. After the First World War and the decline of the Belle Epoque, however, the ideal of the artist at one with society, whose works had a high market value, was no longer current. Stuck's painting class at the Munich Academy had an almost magical attraction for young artists of the most varying backgrounds, whom he inspired to hold heated discussions in Munich's bohemian society. Although Idealism, after Julius Meier-Graefe's critical demolition of both Böcklin and Stuck in 1904, was thought of as out-moded in avant-garde circles, young artists from Germany and abroad

Olaf Gulbransson
Franz Stuck, 1905
Caricature in *Famous Contemporaries* (*Berühmte Zeitgenossen*).
It was an honour to be included in Gulbransson's *Famous Contemporaries*. The well-known caricaturist shows Stuck as aware of himself as a self-assured power on the Bavarian scene, just as he presented himself to society and his students.

Poster for the First International Art Exhibition of the Munich Secession, 1893
Lithograph on paper, 61.5 x 36.5 cm
Munich, Münchner Stadtmuseum

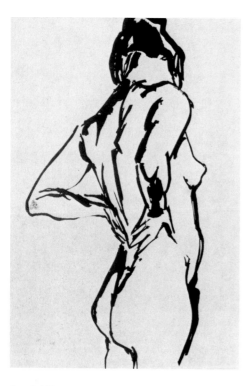

sought admission to the famous artist's painting class. Among his students at the turn of the century were the Czech Eugen von Kahler, the Russian Wassily Kandinsky, the Swiss Paul Klee, the Hungarian Eugen Kossuth, and also the Germans Eugen Spiro, Albert Weisgerber, Hans Purrmann and Willi Geiger. A list of his students in a 1989 catalogue shows that they numbered about 150 up to 1928 and reflected the artistic pluralism of the first half of this century, from post-Impressionism, Expressionism and late Cubism to Neue Sachlichkeit and lastly abstraction.

The students were united in their respect for Stuck's social position, his self-confidence, knowledge of his craft, and his unerring judgement. It was a great honour to be accepted into his painting class because he could afford to reject many applicants. Invited to an introductory discussion in the Villa Stuck, young students brought along their own work. This was not an easy moment for the young students. Paul Klee humorously sketched himself in a letter to his father, portfolio under his arm, on his way to the Villa Stuck in 1900 (ill. p.88 top): from the façade of the Villa a Medusa head and that of the master stared at him, while his dog urinates on the house wall.

Klee was accepted into the class along with Purrmann. The latter was also received into Stuck's painting studio where he showed compositional studies (Stuck "paid little attention to academic or life studies"). In 1947 Purrmann wrote a memoir about his classes with Stuck. He called Klee "an artist who drew exquisite nudes". Kandinsky impressed him primarily as a speaker who warned of "too much school study" and founded a "society of self-styled modern artists" known as the Phalanx, under whose banner he exhibited in Munich. Inspired by Stuck's Secession poster of 1893 with its depiction of an Amazon, Kandinsky designed a Phalanx poster (ill. p.89 top). In *On the Spiritual in Art* (*Über das Geistige in der Kunst*, 1910) Kandinsky placed Stuck as a successor to Böcklin with Rossetti and Segantini among "the seekers on a non-material level." At that time, however, he had already moved a long way away from Stuck artistically.

Josef Albers, who like Klee and Kandinsky later taught at the Bauhaus, attended Stuck's painting class in 1919/20, almost 20 years after these others (ill. p.88 bottom). Albert perceptively explained – like Purrmann retrospectively – the enormous attraction of Stuck as a teacher and artist by the fact that "in an era when Impressionism had triumphed on all fronts, this artist pursued anti-naturalistic goals", strict planar composition and boldness of line. Albers, like Purrmann, thought it necessary to justify his studies with Stuck, and Albers noted that even in the Bauhaus Stuck was mostly spoken about negatively. Only Paul Klee was unapologetic about his alliance with Stuck and declared: "No, I learned from Stuck." Purrmann, for his part, defended Stuck's

personality and the formative period in which he had matured: "It was the Art Nouveau era, which flowered in the middle of his career, although he did not represent the movement himself." The unease and bewilderment that both Stuck's wide-ranging artistic disposition and the difficulty of classifying his achievement caused his contemporaries may be seen in Meier-Graefe, who categorized him as a painting craftsman: "Everywhere artists were moving from the easel to craftwork. Stuck did the opposite." Stuck was not the only important artist trained at an arts and crafts school. The Viennese Secessionist Gustav Klimt received his training at such a school, and both artists were considered excellent illustrators. Stuck's œuvre – and painting is undeniably at its centre – is founded on an aesthetic of unified constructional laws which he developed early in his career by way of his drawings. He was an individualist who forged his own programme: in short, a prince of art who did not belong to any contemporary movement. "In no other city in Germany did the old and the new collide so violently as in Munich," the painter Lovis Corinth remembered. In the work, and in the person of Stuck both came together. Perhaps this is the reason why it is difficult to place him in any one art movement. He combines the characteristics of an Art Nouveau artist, a German-Roman, a Symbolist and an Idealist.

Franz von Stuck worked as a poster artist, a sculptor, designer, architect and photographer, but first and foremost he was a painter. Once the embodiment of modern German art, he became dismissive of the younger moderns. "When I asked the artist his opinion about the latest modern movements, he shrugged his shoulders and said they were nothing but excessive outgrowths containing neither possibilities for further development nor higher goal, and for that reason would be superseded sooner or later." Perhaps he refused the young Viennese painter Egon Schiele his support for precisely this reason. Schiele wrote to Stuck on 15 February: "Dear Herr Stuck! I am on tenterhooks in the sweet hope that my three works might be accepted by the jury for the spring exhibition of the Secession. I am standing alone, as it were, like the grey day behind me, before me a gaping precipice, and up there happiness surrounded by blinding light. Here I stand, helpless and without means, at a dizzying height without a secure foothold. One word from your divine being will suffice

Wassily Kandinsky
Poster for the First Phalanx exhibition, 1901
Colour lithograph on paper, 47.3 x 60.3 cm
Munich, Städtische Galerie im Lenbachhaus

Karl Arnold
Professor Franz von Stuck at Work, 1906
Professor Franz von Stuck bei der Arbeit

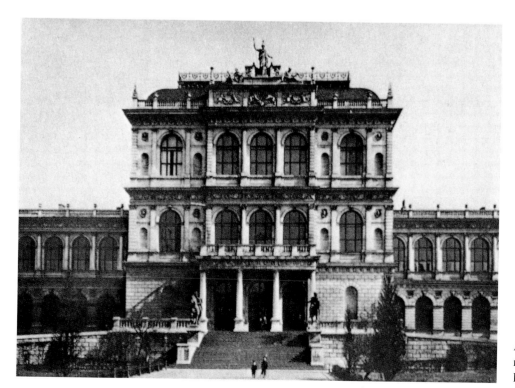

Academy of Fine Arts, Munich:
main entrance
Photograph

[handwritten letter in German with heading "Wien 15.II.1909."]

to ensure that my first works will be accepted..." Despite his susceptibility to the "divine", Stuck seems not to have exercised his influence on behalf of the young artist.

Stuck established no personal contacts with his students. He gave them artistic freedom, reinforced their individual artistic directions and did not push them towards imitation of his style. There was no "Stuck school" as there was a Piloty school, a Diez school, or a Barbizon school. But Stuck does seem to have propounded certain aesthetic principles from time to time that have still been taken as valid in the twentieth century. Albers, who very much valued Stuck's drawings during his student days, affirmed the older artist's theory of colour from his own experience, in reversal of the twentieth century's negative judgement that Stuck was weak as a colourist: "I can see Stuck in front of me now, explaining his theory of colour with incisive hand gestures. He would hold his hands upright with palms inward towards him, moving them towards and back from the listener. Cold and warm colour, Stuck liked to say, have different spatial and planar qualities, with regard to whether and to what extent they advance or recede. Colours either advance or recede on the paint surface by virtue of their intrinsic qualities. Light colours are cold and recede, dark colours are warm and thrust themselves forward." These principles can still be observed in one of Stuck's last uncompleted works, *Wind and Wave* (1928; ill. p.91 top).

Since the turn of the century Stuck's work has undergone changing and very different judgements by other artists, critics, and last but not least the public itself. It is not coincidental that a rediscovery of this artist occurred in the late 1960s and 1970s. At that time there was increased public interest in the Art Nouveau era, and this revived new interest in Stuck. In 1968, for example, the Villa Stuck was opened to the public with the support of the Stuck Jugendstil Association; in 1973 the first catalogue of his paintings was published. Stuck's work and personality were researched, and exhibitions in the Villa Stuck introduced selected aspects of his œuvre and afforded introductory glimpses of the artist and his work. At the end of the 1980s, on the initiative of a dedicated husband and wife from Lower Bavaria, a museum was opened in Stuck's birthplace at Tettenweis, where there has since been an active exhibition programme supported by his descendants. In 1992 a foundation was set up whereby ownership and administration of the Villa Stuck were transferred to the city of Munich.

At the present time there is strikingly growing interest in Stuck's personality and work, in which affinities to post-Modernism are being discovered. It may be said with certainty that more than a hundred years after the painting of *Sin*, and after the experience of so many different movements in modern and contemporary art, we can today be more open to Stuck's work than his students were.

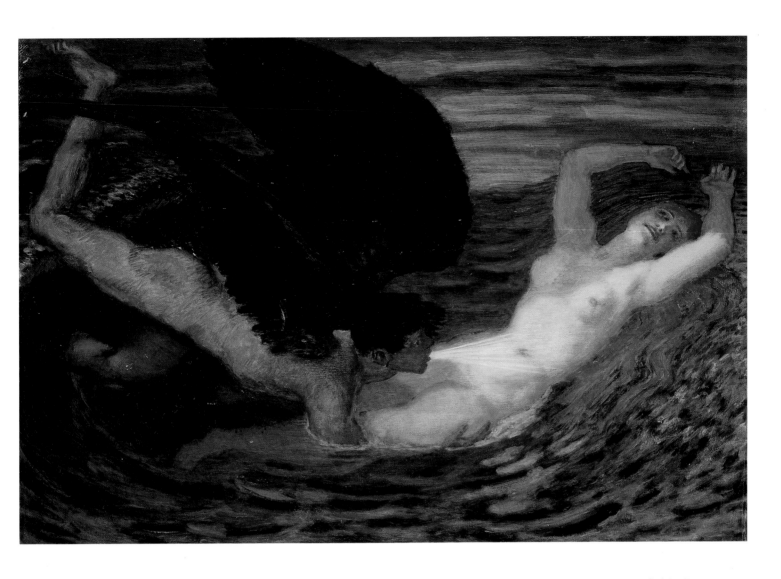

Wind and Wave, 1928 (unfinished)
Wind und Welle
Oil on canvas, 68 x 100.5 cm
Estate of the artist

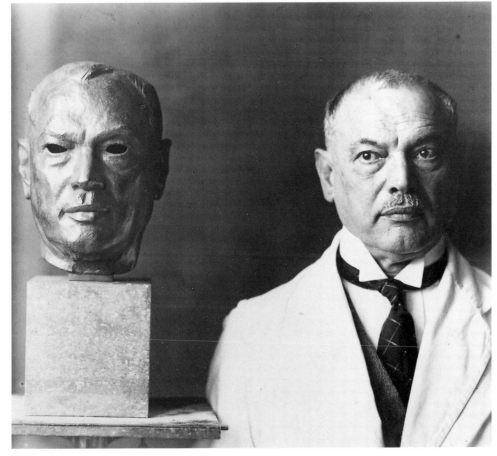

Franz Stuck next to a head by Bernhard
Bleeker, 1927
Photograph
Estate of the artist
Franz von Stuck died in August 1928. A
funeral address included the words:
"A prince in the realm of art, the last prince
of art of Munich's great days, has departed."

Franz von Stuck 1863–1928: A Chronology

1863 Born on 23 February 1863 in the village of Tettenweis in Lower Bavaria, of Catholic parentage, his father a miller.

1869 The young student is nicknamed "Painter". He is always drawing, and caricatures local villagers.

1878 His mother succeeds in getting him into a secondary school. After he finishes his course at the Royal High School in Passau, his father agrees to his training at the Royal College of Arts and Crafts in Munich, although he would have preferred him to become a miller. There Franz develops his drawing abilities. This technical and practical training forms the foundation of his later career as a painter, sculptor, craftsman and also architect.

1881 Stuck studies until 1885 at the Royal Academy of Fine Arts in Munich under Wilhelm Lindenschmit and Ludwig Löfftz. According to his own testimony, he frequently fails to attend the Academy, earning his living as an illustrator instead.

Stuck at the age of nine, 1872

1882 Stuck is commissioned to illustrate *Allegories and Emblems* (*Allegorien und Embleme*) to be published by Gerlach and Schenk. He makes a name for himself as an outstanding draughtsman.

1886 *Cards and Vignettes* (*Karten und Vignetten*) containing illustrations by Stuck, published by Gerlach and Schenk. Works from 1887 to 1892 as a caricaturist for the Munich magazine *Broadsheets* (*Fliegende Blätter*). In 1888 he contributes drawings to *The Twelve Months* (*Die Zwölf Monate*).

1889 Stuck exhibits paintings for the first time. He shows three oil paintings at Munich's Crystal Palace: *Innocentia*, *Fighting Fauns* and *The Guardian of Paradise*, all of which are considered controversial. The Guardian of Paradise wins a gold medal, and Stuck receives a prize of 60,000 marks.

Franz Stuck, c. 1888

1892 The Munich Secession is founded. Stuck is one of the founding members with Hugo von Habermann, Bruno Piglhein and Fritz von Uhde, among others. He exhibits his first small sculpture.

1893 Stuck wins a medal at the World's Fair in Chicago. In Munich he is appointed to a royal professorship. The progressive movement in Munich, the Secession, the poster for whose opening exhibition has been designed by Stuck, thus receives official support. Young people flock to the Secession's exhibition to see Stuck's latest sensational work, *Sin*.

1895 The popular artist is appointed professor at the Royal Academy of Art, in Munich. Paul Klee, Wassily Kandinsky and Josef Albers attend his painting class over the years. Stuck's paintings continue to provoke with the boldness of their subject matter and composition. The police ban public display of reproductions of *The Kiss of the Sphinx*.

Memento of the year 1896: Stuck with the mother of his daughter, Anna Maria Brandmeier, and his future wife, Mary Lindpainter

Franz and Mary Stuck in Greece, 1904

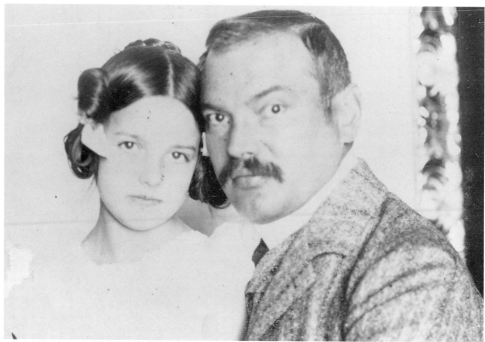

Franz von Stuck and his daughter Mary, c. 1900

1896 On 9 April Stuck's daughter Mary is born out of wedlock. Her mother is Anna Maria Brandmeier, and her godmother Mary Lindpainter.

1897 Stuck marries the American Mary Lindpainter, who lives in Munich, and they later adopt his daughter Mary. At the International Art exhibitions in Munich – where he shows among other works *Fighting Amazon* – and Dresden, Stuck receives a medal for painting and a distinguished gold medal.

1898 Stuck has a residence, including studio, built by the firm Heilmann and Littmann according to his own designs, which extend to the interior decoration throughout, including the furniture as well as the placing of paintings and sculptures. Stuck is now seen as a "prince of art", and takes his position in the first rank of European artists.

1900 For the furniture of his Villa Stuck receives a gold medal at the World Exposition in Paris. In this year several artists later of major stature attend his painting class, among them Paul Klee and Wassily Kandinsky.

1902 Stuck paints the double portrait *Franz and Mary Stuck in the Studio*; Thomas Mann caricatures the role of art and artists in Munich in his novella *Gladius Dei*.

1904 Stuck, whom contemporaries call "neo-Greek" or "neo-Roman", visits Greece with his wife. There are no evident traces of this visit in his work.

1906 On 9 December 1905 Prince Regent Luitpold of Bavaria confers on Stuck the

Knight's Cross of the Order of Merit of the Bavarian Crown, elevating him to the aristocracy. At the height of his social career, Stuck's artistic validity is called into question outside Munich because of the spectacular nature of his subject-matter and the decorative quality of his paintings.

1909 Italian critics praise Stuck in Venice where he shows among other work *Family Portrait* and *Spring Dance* dating from this year. He is honoured with the Italian orders of St Mauritius and St Lazarus. In Munich Hanfstaengl publishes Fritz von Ostini's major monograph on Stuck, with excellent reproductions.

1913 Fiftieth birthday, commemorated by the paintings *The Dinner* and *Torch Procession*. The small sculpture *Spear-throwing Amazon* (1897/98) is recast life-size in a slightly different form.

1914 The firm of Heilmann and Littmann constructs a new studio with special facilities for sculpture. The sculpture *Surrounded by Enemies*, made at the beginning of the First World War, is a rare work with a reference to current events.

1917 Stuck's daughter Mary marries Consul Albert Heilmann. Stuck becomes a Member of the Viennese Academy of Arts.

1919 Stuck is a hostage of the Red Guards for several days. Neither the war nor post-war events are reflected in his works of this time, among them the painting and sculpture entitled *Faun and Sea-Nymph* (1918).

1920 Joseph Albers attends Stuck's painting class. Stuck rejects the "most modern

movements in art". In *Pan* and *Sisyphus* he takes up the themes of his earlier works.

1926 Stuck becomes a member of the Royal Academy of Art, Stockholm and a Freeman of the University of Munich. His importance as a sculptor is recognized.

1928 The Technical University in Munich confers an honorary doctorate of engineering on Stuck shortly before his death. On 30 August Munich's last "prince of art" dies.

Franz von Stuck, c. 1926

Bibliography

Bierbaum, Otto Julius, *Franz Stuck, Künstlermonographie*, Bielefeld and Leipzig, 1901

Germain, André, *Franz Stuck & Leo Samberger, Les idées dans la peinture allemande contemporaine*, Paris 1903

Heilmann, Angela, *Die Plastik Franz von Stucks. Studien zur Monographie und Formentwicklung*, Munich 1990

Hoh-Slodczyk, Christine, *Das Haus des Künstlers im 19. Jahrhundert*, Munich 1985

Makela, Maria, *The Munich Secession*, New Jersey 1990

Mendgen, Eva, *Künstler rahmen ihre Bilder*, Constance 1991

Ostini, Fritz von, Franz Stuck, in: *Die Kunst für Alle*, Munich 1903

Singer, Hans W., *Franz von Stuck, Meister der Zeichnung*, Leipzig 1912

Voss, Heinrich, *Franz von Stuck 1863–1928*, Munich 1973

Exposition catalogues

Franz von Stuck, Ausstellung zur Wiedereröffnung der Stuck-Villa, Munich 1968

Fotografische Bildnisstudien zu Gemälden von Lenbach und Stuck, Essen 1969

"München leuchtete", Munich 1984

Stuck und seine Schüler, Munich 1989

Der Künstler und seine Villa, Tettenweis 1991

Die Villa Stuck in München. Inszenierung eines Künstlerlebens, Munich 1992

Franz von Stuck und die Münchener Secession, Tettenweis 1993

Franz von Stuck: Gemälde, Zeichnung, Plastik aus Privatbesitz, Passau 1993

Eva Mendgen

Born in 1959 in Stuttgart, Eva Mendgen studied History of Art, Ancient History and Comparative Religion at Freiburg, Bonn, Aachen and Berkeley. She has lectured at the University of California, Santa Barbara and at the Saar School of Fine Arts; in 1995 she acted as guest curator at the Van Gogh Museum in Amsterdam for the exhibition "In perfect harmony. Picture and Frame 1850–1920". She has published a number of books and articles on painting, the applied arts and design in the nineteenth and twentieth centuries.

Acknowledgements

This title would not have seen the light of day without the generous support of Eva Heilmann, trustee of the Franz Stuck estate. The author and publisher wish to express particular gratitude to her.
Their thanks also to Albert Ritthaler of the Galerie Ritthaler, Munich, as well as to Edwin Becker of the Van Gogh Museum, Amsterdam, for their help in researching the subject.
The publisher also wishes to thank the museums, collectors and photographers who have assisted in compiling this book.
Among others already mentioned in the illustrations' captions, we wish to thank:
Artothek Peissenberg: 8 left, 9 right, 17, 18, 27, 69, 85 bottom

Angela Bröhan, Munich: 8 right, 13, 14 top, 14 bottom, 15 top, 36 left, 39, 40, 44 bottom, 50, 55 left, 56 right, 58 top, 59, 65 bottom, 68 bottom, 71, 76 left, 83, 92, 93 top, 94 top left, 94 top right
Museum Moderner Kunst, Passau: 37, 38, 41, 66, 70, 72, 74 bottom, 75 top, 78 right, 90
Fotostudio Otto, Vienna: 23
©Wolfgang Pulfer, Munich: 29, 86
Dr Alexander Rauch, Munich: 20, 48, 64 bottom, 77
Rheinisches Bildarchiv, Cologne: 21
Galerie Ritthaler, Munich: 41 bottom, 47, 48, 57 left, 77, 82
Christoph Seeberger, Munich: 73
Süddeutscher Verlag, Munich: 7

In this series:

- Arcimboldo
- Bosch
- Botticelli
- Bruegel
- Cézanne
- Chagall
- Christo
- Dalí
- Degas
- Delaunay
- Duchamp
- Ernst
- Gauguin
- van Gogh
- Grosz
- Hopper
- Kahlo
- Kandinsky
- Klee
- Klein
- Klimt
- Lempicka

- Lichtenstein
- Macke
- Magritte
- Marc
- Matisse
- Miró
- Monet
- Mondrian
- Munch
- O'Keeffe
- Picasso
- Rembrandt
- Renoir
- Rousseau
- Schiele
- von Stuck
- Toulouse-Lautrec
- Turner
- Vermeer
- Warhol

EX LIBRIS

FRANZ
VON
STVCK